Stained Glass

Stained Glass

RADIANT ART

Virginia Chieffo Raguin

The J. Paul Getty Museum · Los Angeles

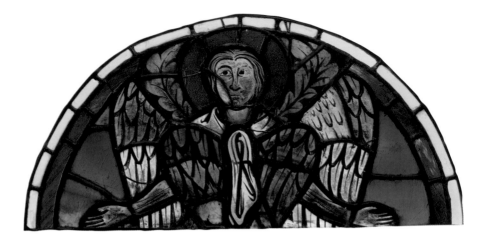

© 2013 J. Paul Getty Trust

Published by the J. Paul Getty Museum
Getty Publications
1200 Getty Center Drive, Suite 500
Los Angeles, CA 90049–1682
www.getty.edu/publications

Beatrice Hohenegger, Editor
Kurt Hauser, Designer
Suzanne Watson, Production Coordinator

Printed in China

Library of Congress Cataloging-in-Publication Data
Raguin, Virginia Chieffo, 1941- author.
 Stained glass : radiant art / Virginia Chieffo Raguin.
 pages cm
 Includes bibliographical references and index.
 ISBN 978-1-60606-153-4 (pbk.)
 1. Stained glass windows. 2. Glass painting and staining.
 I. J. Paul Getty Museum. II. Title.
 NK5306.R345 2013
 748.5--dc23
 2013008468

Front cover: *Head of an Angel or Saint*, ca. 1410
(detail of fig. 65)
Back cover: *Saint George with the Arms of Speth*,
1517 (detail of full image on p. 6)
Page 1: *Heraldic Panel*, ca. 1520–30 (detail of fig. 35)
Pages 2–3: *Saint John*, ca. 1420 (detail of fig. 29)
Page 4: *Seraph*, ca. 1275–99 (full image; detail in
fig. 70)
Page 6: *Saint George with the Arms of Speth*, 1517
(full image; detail in fig. 13)
Page 8: *The Archangel Michael Vanquishing the
Devil*, ca. 1530 (detail of fig. 11)
Page 54: *Heraldic Panel with the Arms of the Eberler
Family*, ca. 1490 (detail of fig. 45)
Page 86: *Saint Christopher and a Donor*, ca. 1500–
1510 (detail of fig. 41)

Illustration credits
Every effort has been made to contact the owners
and photographers of objects reproduced here
whose names do not appear in the captions or in the
illustration credits at the back of this book. Anyone
having further information concerning copyright
holders is asked to contact Getty Publications so this
information can be included in future printings.

Contents

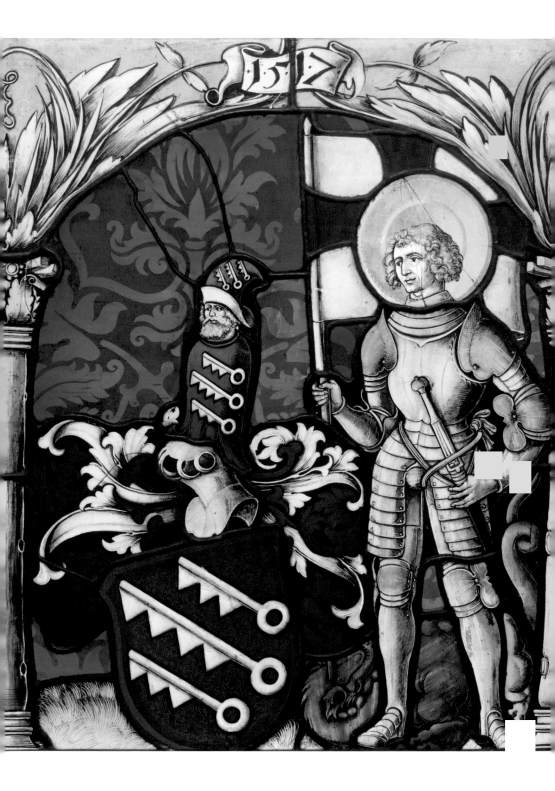

Foreword

Stained glass was an integral part of the architecture of the Middle Ages and Renaissance, inspiring the lives of the faithful through religious narratives in churches and cloisters, celebrating family and political ties in city halls, and decorating the windows of elite private homes. Illuminated by transmitted rather than reflected light, stained glass inspired a special sense of wonder and mystery that was rich in symbolism—heavenly light from the sun traversing matter to produce radiant images that evoke the mystery of creation and the passage of time as light rises and falls in a window over the course of each day. The beauty and precious delicacy of these images have been admired by collectors ever since.

In an age when the most spectacular art commissions were overwhelmingly for the Church, it is no surprise that stained glass was one of the foremost techniques of painting practiced in Europe. At first, tint was supplied exclusively by the separate pieces of colored glass, and details were applied onto the surface with a vitreous paint in a range of dark tones. Painting was usually done in several layers on the front of the glass; the back also could be painted to lend shading and three-dimensional effects to an image. Over time, glass workers and painters developed a wide variety of other methods to manipulate and embellish the glass and create more elaborately colored and detailed pictures. The term "stained glass" refers to only one of these techniques.

Highlighting unique works from the collection of the J. Paul Getty Museum, this publication provides an introduction to the production and artistic achievement of stained glass in the centuries of its greatest flourishing. The impact that these creations had on kings and commoners alike is well summed up by the German monk Theophilus, who wrote in the twelfth century: "if [a human eye] gazes at the abundance of light from the windows [in a church], it marvels at the inestimable beauty of the glass and the variety of this most precious workmanship" (*On Divers Art*, Book 3, Prologue).

Timothy Potts
Director
The J. Paul Getty Museum

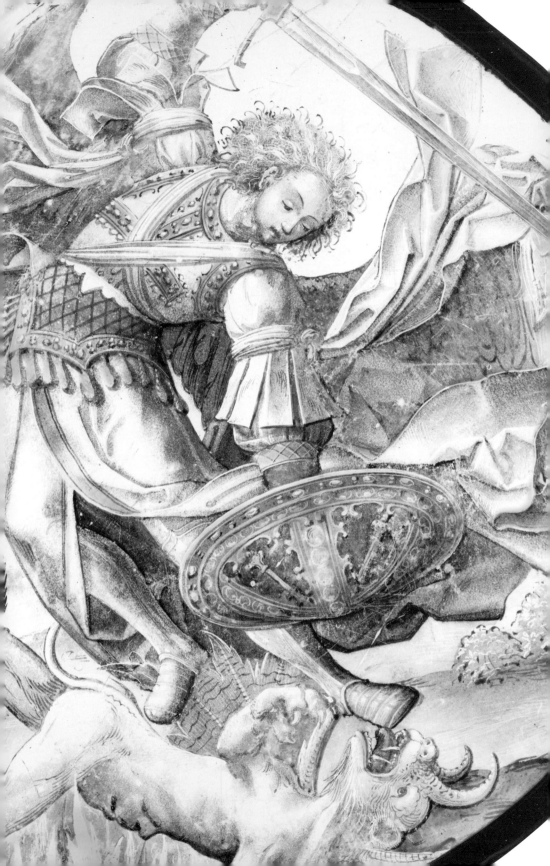

Introduction

STAINED GLASS WINDOWS were essential features of medieval and Renaissance buildings, providing not only light to illuminate the interior but also specific and permanent imagery that proclaimed the importance of place. Stained glass is a monumental art, a corporate enterprise dependent on a patron with whom the artists blend their voices. Commissioned by monks, nuns, bishops, kings and queens as well as by merchants, prosperous farmers, and a host of anonymous patrons, the windows vividly reflect the social, religious, civic, and aesthetic values of the eras in which they were made.

Combining the disciplines of decorative arts, architecture, and painting, stained glass windows transform our experience of space. To conceive of how viewers in the past could have seen these ensembles, vital to both church and state from the twelfth through the sixteenth centuries, we might consider the public response to contemporary, large-scale installation art. Our perceptions of the late-medieval Roman Catholic church of Saint-Séverin in Paris (fig. 1), for example, and of Patrick Dougherty's open-air installation *Simple Pleasures* (fig. 2)—created in 2001 for Bowdoin College Museum of Art in Brunswick, Maine—change with the seasons, the times of day, and the visitors' physical interaction with each of the two structures. Light, color, and space are the artist's materials in both creations: the light falling through glass on the church's interior spaces and

Fig. 1 · Triforium and clerestory windows, 1480s, church of Saint-Séverin, Paris

sculpted forms against the brilliance of a New England autumn in the Dougherty installation. Whether made of stone or bent twigs, these works of art engage spectators through rituals of passage. Both the medieval glass and the contemporary installation required the labor of numerous collaborators. *Simple Pleasures* involved college administrators, environmental supervisors, tree farmers, and professional and volunteer installers. For the stained glass windows, the team included supervising architects, church authorities, religious scholars, glass producers and blowers, painters, and metalworkers.

In 2003 the J. Paul Getty Museum acquired, in toto, its collection of stained glass, encompassing panels dating from about 1210 to about 1575. The holdings contain examples of the medium produced in Austria, Belgium, England, France, Germany, the Netherlands, and Switzerland. Subject matter depicted in the panels ranges from monumental religious scenes for Gothic churches to lively heraldic panels made for houses and other secular settings.

Before obtaining this remarkable collection, the Getty showcased its existing group of designs for windows in the 2000 exhibition *Painting on Light: Drawings and Stained Glass in the Age of Dürer and Holbein.* The enthusiastic response to that presentation

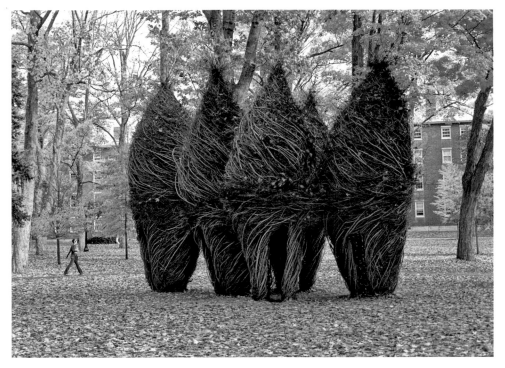

Fig. 2 · Patrick Dougherty (American, b. 1945), *Simple Pleasures*, 2001. Interwoven branches. Brunswick (ME), Bowdoin College Museum of Art

demonstrated the public's interest in this compelling art form—its dazzling colors, its range of subject matter, and the intriguing way it is made. In 2010 a large portion of works in the stained glass collection acquired in 2003 was installed in the renovated medieval and Renaissance sculpture and decorative arts galleries at the Getty Museum, where it reveals the intersection of painted and leaded windows with works of sculpture, metalwork, paintings, and illuminated books. In the Renaissance, it should be noted, some of the same artists who created paintings and prints also designed works in glass. Essentially a form of painting on a translucent medium, stained glass varies little from the period expression of other arts.

The discussion of the museum's panels in the present volume illustrates their association with comparable pieces from other artistic genres. These include works on paper—both drawings and preparatory sketches for windows—late-medieval oil paintings, glass vessels, and especially works from the museum's renowned illuminated manuscripts collection, begun in 1983 with the purchase of the holdings of Peter and Irene Ludwig of Aachen, Germany.

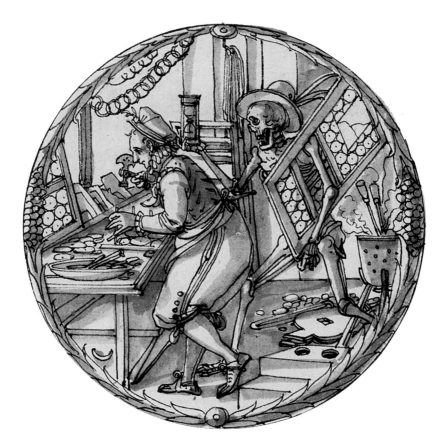

Fig. 3 · Daniel Lindtmayer (Swiss, 1552–1606/7), *Death and the Glazier* from the series Dance of
Death, 1592. Pen and black and brown ink, diam.: 11.5 cm (4½ in.). Göttingen State and
University Library, 2 cod Ms. Uffenbach 40c, Bl.38

Materials and Techniques

The process of making stained glass has changed little over time. In the early twelfth century, a monk using the pseudonym Theophilus wrote a treatise entitled *On Divers Arts*, in which he described the basic steps required to make sheets of transparent colored glass and to fabricate a window. Despite the passage of time, and allowing for innovations and refinements, these techniques are, essentially, still practiced. A sixteenth-century drawing by the Swiss artist Daniel Lindtmayer for a small window roundel shows a glazier at his worktable, using a variety of tools to insert circles of glass (bull's-eyes) into a window's matrix (fig. 3). The skeletal figure of Death interrupts his work by holding up an hourglass to show that his time has run out. Popular in the late Middle Ages and Renaissance, these representations of mortality profiled occupations, conveying the inevitability of death for all.

The production of glass objects preceded the introduction of stained glass by millennia, dating to early antiquity. Examples of core-formed and molded glass from Egypt and Mesopotamia date to the fifteenth century BCE. In these processes, molten glass is applied to a temporary core to form a vessel or poured into a mold to form an object. Blown glass was probably invented around the fifth century BCE, and with the expansion of the Roman Empire in the first century of the common era, glass jars for ointment and perfume, drinking vessels, and medicine containers were major items of exchange throughout Europe. Often these items were luxury goods, such as a wine cup dated to 25 BCE–25 CE (roughly, the years encompassing

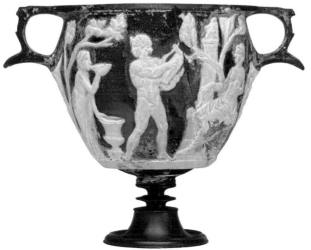

Fig. 4
Wine Cup with Scenes of Bacchus and Ariadne, Roman, 25 BCE– 25 CE. Cameo glass, 10.5 × 17.6 × 10.6 cm (4 1/8 × 6 15/16 × 4 3/16 in.). JPGM, 84.AF.85

the reign of the Roman emperor Augustus) depicting Bacchus and Ariadne (fig. 4). The object illustrates the technique of casing, in which glass of one color is enveloped with glass of another color to produce two contrasting layers; this process was revived in the Middle Ages. Here, the outer shell of opaque white glass has been cut away to suggest the look of a cameo.

Producing Sheets of Glass

Stained glass artists in earlier times rarely made their own glass; nor do they today. The fabrication of leaded and painted windows and the production of the raw materials are two different, highly specialized disciplines. Some stained glass workshops were located near glassmaking facilities. Most of the time, however, producers of sheet glass preferred to set up shop near the sources of the raw materials they needed, such as sand and ash. Indeed, a number of medieval accounts detail the cost of transporting finished sheets of glass to workshops located some distance away.

The production of glass requires three basic ingredients: silica, an alkali, and an alkaline earth. Silica, usually in the form of sand, forms the vitreous network of glass. By itself, silica requires a very high heat in order to melt, so the glassworker introduces a so-called network modifier, in the form of an alkali, to break up the strong silica bonds and lower the temperature. In medieval glass, this material was lime, an alkaline earth added to rebuild the network and thus produce a stable material. When the three basic components are heated to a temperature ranging from about 2400°F to 2700°F (1300°C to 1500°C), they fuse together to form glass (fig. 5).

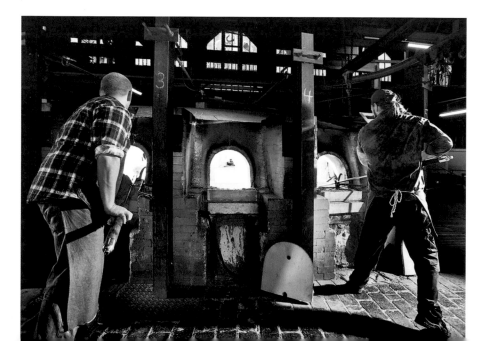

Various metallic oxides may be added to color a batch of glass. A skilled glassblower could observe what color glass the materials yielded as sheets were being blown and then manipulate the furnace vents to produce an oxygen-rich or oxygen-poor environment in order to obtain other colors from the batch. Specific colorants were also added, such as cobalt for blue and copper for red.

Traditionally, one of two methods was used to form sheets of glass. The crown method, used in the thirteenth and fourteenth centuries, produced glass that tended to be relatively thick and heavy. The glassblower gathered a globule of molten glass on a pipe and blew a bubble, which was transferred to a metal pipe, called a pontil. The glassblower then pierced the bubble and spun the pontil, which caused the glass bubble to spread out into a flat, circular shape. As a result of the centrifugal motion, the glass was thicker toward the center of the circle.

Increasingly during the fifteenth and sixteenth centuries, glassmakers used a second method—called the muff, or cylinder, technique (fig. 6). In this method, the glassblower produced a long, cylindrical shape, one end of which was removed by a coworker. In a careful process during which the glass was periodically put back into the kiln, the opposite end was also removed, the cylinder was then split down the side, and the heat caused the glass to relax and lay flat. The resulting glass sheets were thinner, lighter, more even, and usually larger than those yielded by the crown method. The creation of larger glass sheets allowed artists to paint more detailed and illusionistic imagery onto stained glass windows; this paralleled the development of three-dimensional modeling in illuminated manuscripts and panel paintings of the late Middle Ages.

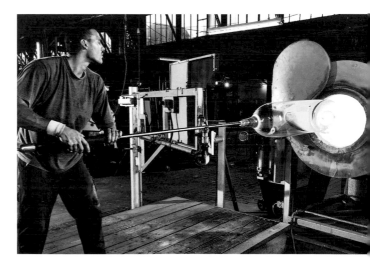

◁ Fig. 5
Raw materials are melted in a furnace at the beginning of the production of glass panes. Glashuette Lamberts Waldsassen GmbH

Fig. 6 ▷
Glass cylinders are put back into the furnace just before they are opened flat. Glashuette Lamberts Waldsassen GmbH

The sheets that were produced by these methods needed to be cut to the specific shapes necessary for incorporation into a panel of stained glass. In the Middle Ages, artisans scored glass sheets with a hot iron tool. Adding a cooler element, such as water or saliva, caused the glass to crack and helped the sheet to split. The development of harder alloys able to take a sharper edge made it possible to score the glass with deeper grooves that initiated a break more easily. The roughly shaped edges of the split glass were then refined with a grozing iron, a short metal rod with a slot or hook at each end. An edge of the glass was slipped into the hook, and the action of pulling the iron down and away nibbled the edge into shape. Today, the stained glass artist uses a pair of specially designed pliers for the same purpose.

Painting on Glass

With rare exceptions, medieval and Renaissance stained glass was painted. Neutral-color paint could be thinned to produce a wash of varying shades, or applied as an opaque accent. Various techniques were used to apply the paint, but the goal was always the same: to produce an image and modulate the light so as to strike a harmonious balance of lighter and darker colors.

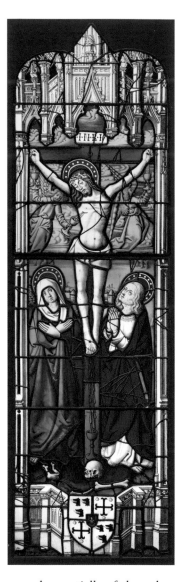

The paint used for stained glass is vitreous, composed essentially of clear glass ground to a powder and opaque metallic oxides. This was mixed with a binder, such as vinegar or wine, applied with a brush, and then fired in the kiln. These days, a stained glass artist can purchase powdered forms of vitreous paint in a limited range of opaque colors, from brick red to brown to black. In explaining how to make stained glass windows, Theophilus paid particular attention to paint-application techniques, instructing the painter to "smear [the pigment] about with the brush in such a way that . . . the glass is made transparent in the part where you

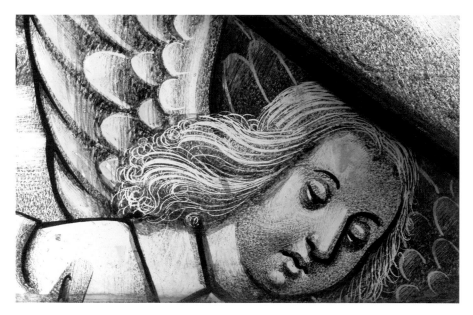

Fig. 7 · *The Crucifixion*, French (Lorraine/Burgundy), ca. 1500–1510. Pot-metal, flashed, and colorless glass, vitreous paint, and silver stain, 225 × 64 cm (88 ⁹⁄₁₆ × 25 ³⁄₁₆ in.). JPGM, 2003.53.1. Full image (*opposite*); detail of an angel (*above*)

normally make highlights in a painting," such as around the eyes, nostrils, and chin and on bare feet and hands.[1]

Theophilus also wrote of removing paint, also before firing, in a variety of ways in order to make "circles and branches with flowers and leaves . . . as is done in the case of painted letters [in manuscripts]."[2] Although these techniques of removal are reflected in numerous glass panels, some of the most striking examples are seen in a monumental Crucifixion from France, in which angels hold chalices receiving the sanctifying blood from Christ's wounds (fig. 7, full image). In the area of the wings, the artist added yellow-green highlights through a process called silver stain—described below (fig. 7, detail). As in many stained glass windows made in the early sixteenth century, the segments of glass here are large, and the image is created with paint. The artist laid down a light mat of obscuring paint and next added darker values for areas of shadow. He then defined the wings, clouds, garments, and hair by removing the paint and adding dark outlines. He also employed the techniques of stippling, dabbing the paint with the butt of the brush to let in minute points of light, and stickwork, using a pointed tool to scratch out details or highlights in certain areas before firing. The rhythm of the lines of the angel's flowing hair sensitively complements the solid mass of his cheek.

Silver Stain

A significant innovation in glass painting occurred around the beginning of the fourteenth century. Called silver stain, this technique is the only true *stain* in stained glass. Since the eighth century, Islamic glassworkers had used silver stain as a colorant in painting designs on their vessels; these became prized luxury-import items during the Middle Ages (fig. 8). As the Christian Spanish kings of Aragon and Castile expanded their influence on the Iberian Peninsula, Western artisans adopted this Islamic technique, which involves, first, applying a silver oxide in an opaque medium, usually to the back of the glass. Next, during firing, silver ions from the oxide penetrate the glass substance, instead of being fused onto the surface, as is the case with glass paint. After firing, the opaque medium is removed from the glass, revealing the transparent yellow produced by the silver stain process. Glass can be stained in shades ranging from lemon yellow to deep amber, depending on the composition of the glass and stain, the number of applications, and the temperature of the kiln.

Originally, artists used the stain as a decorative wash, as seen in an English angel dating to about 1420–30 (fig. 9). Here, a single tone of silver stain accents the outer edge of the halo, the exuberant curls of the hair, and the loosely drawn floral elements of the robe. Later artists developed more complex applications. In

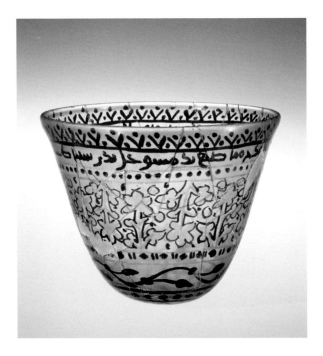

Fig. 8
Cup, Syrian (Damascus), 700–799(?) CE. Uncolored glass with a bluish tint; blown, stained, tooled, h.: 10 cm (3 ¹⁵⁄₁₆ in.); diam. (rim): 13.2 cm (5 ³⁄₁₆ in.). Corning (NY), The Corning Museum of Glass, 69.1.1

Fig. 9 ▷
An Angel, English (Midlands?), ca. 1420–30. Colorless glass, vitreous paint, and silver stain, 14.9 × 9 cm (5 ⅞ × 3 ⁹⁄₁₆ in.). JPGM, 2003.39

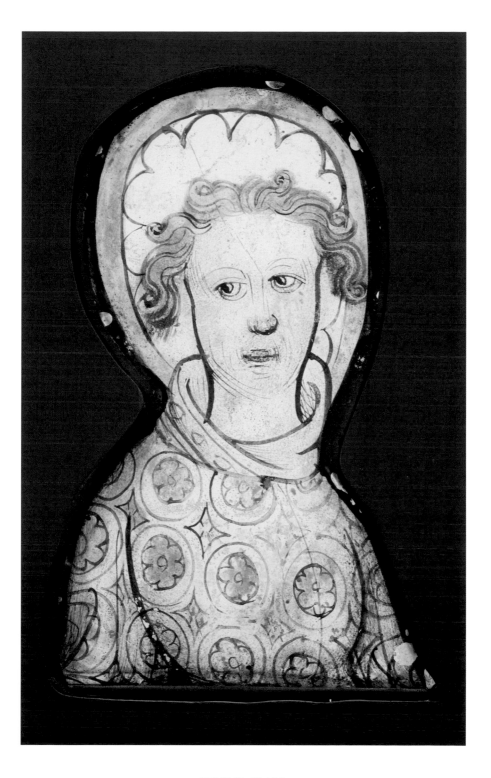

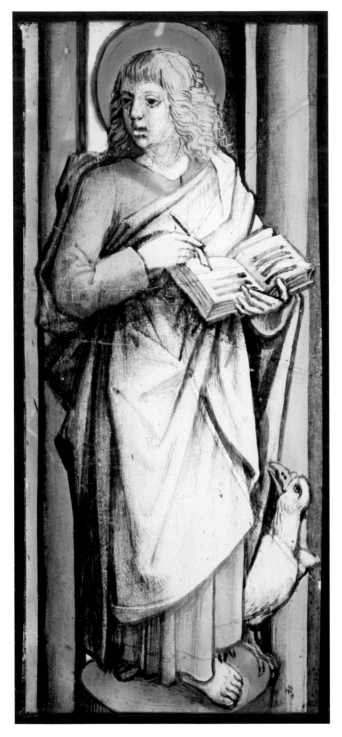

Fig. 10
Saint John the Evangelist,
Netherlandish (Bruges?),
ca. 1490. Colorless glass,
vitreous paint, and silver
stain, 20.5 × 11.3 cm
(8 ¹/₁₆ × 4 ⁷/₁₆ in.). JPGM,
2003.51.2

Fig. 11 ▷
*The Archangel Michael
Vanquishing the Devil*,
South Netherlandish (?),
ca. 1530. Colorless glass,
vitreous paint, and silver
stain, diam.: 26.9 cm
(10 ⁹/₁₆ in.). JPGM, 2003.73

an image of Saint John the Evangelist produced in the southern Netherlands about 1490, silver stain appears as a variegated pigment; two distinct tones of stain, in the figure and the architectural frame, enhance a sense of the figure's three-dimensionality (fig. 10; see also fig. 72, which illustrates the panel before restoration).

Two shades of silver stain are also evident in *The Archangel Michael Vanquishing the Devil* (fig. 11), possibly from the southern Netherlands and made about 1530. The trim of the armor, Michael's cuffs, Satan's mouth, and the flames of hell reveal a dark silver stain; a lighter shade appears in the archangel's hair and in the landscape. Both light and dark shades serve to create the convex form of Michael's shield. Sanguine, a reddish pigment similar to silver stain, is used for Satan's tongue, the lower segment of Michael's body armor with the lozenge design, his cuffs, and the shield.

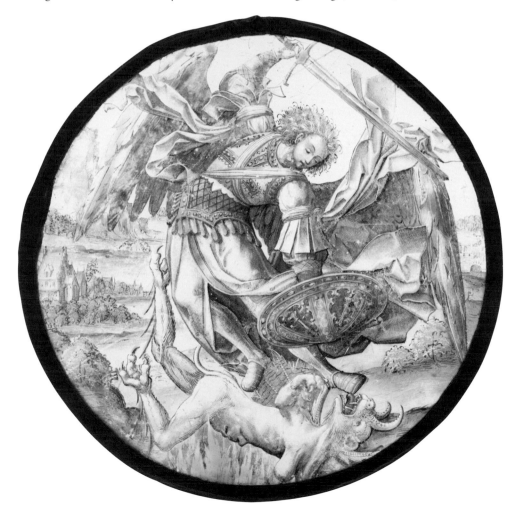

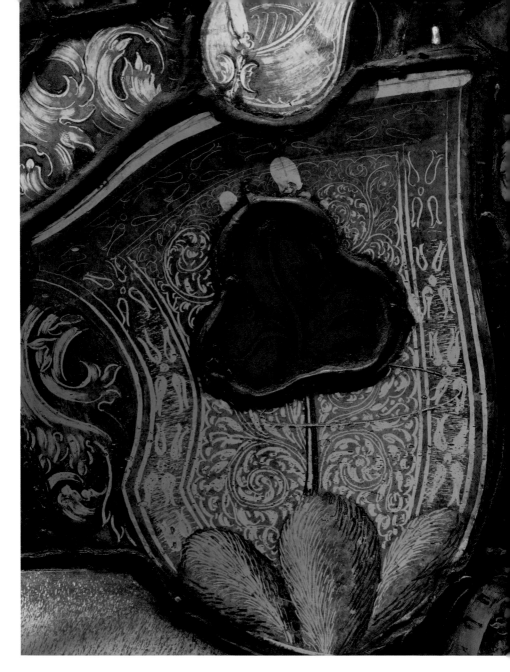

When silver stain was fired onto blue glass, it created the color green. The result can be seen in the green lining of the Virgin Mary's robe in a monumental Crucifixion, created about 1500–1510 in Lorraine/Burgundy (see fig. 7), as well as in the green triple mount in the shield of the small-scale Swiss *Suicide of Lucretia* of 1561 (fig. 12). This shield also shows an example of chef d'oeuvre, a specific stained glass technique of inserting a small piece of glass—here, the red trefle (tri-lobed

◁ **Fig. 12**
Detail of the shield from
The Suicide of Lucretia (fig. 48)

Fig. 13 ▷
Detail of the back of the shield
from *Saint George with the
Arms of Speth*, German, 1517
(p. 6). Pot-metal, flashed, and
colorless glass, vitreous paint,
and silver stain, 54.3 × 46.4 cm
(21⅜ × 18¼ in.). JPGM, 2003.64

leaf)—into a hole abraded through the blue glass and held in place with lead. The glass of the trefle and the shield were also embellished with vitreous paint to produce the decorative pattern on the blue shield, the blades of grass of the green mount, and the contours of the red leaf.

In the fourteenth century, artists began to exploit flashed, or double-layered, glass, which was produced by a technique called casing. (Casing was used to produce Roman vessels in cameo glass [see fig. 4]). In casing, a molten gather (a glob of glass adhering to a blowpipe) of one color is coated with a thicker gather of a different hue, most frequently uncolored glass. This layered gather is then blown into a sheet. After cooling, areas of the thin flash can be removed by abrasion to reveal the color of the base glass. Artisans favored this method to achieve intense colors, such as red. During the later fifteenth century, some artists (most notably the Peter Hemmel von Andlau Workshop in Strasbourg) began using acid to remove flash. The coat of arms in the early sixteenth-century German *Saint George with the Arms of Speth* offers a brilliant example of flashed glass; the thickness of the two layers and the scratch marks left from abrasions appear on the reverse in raking light (fig. 13).

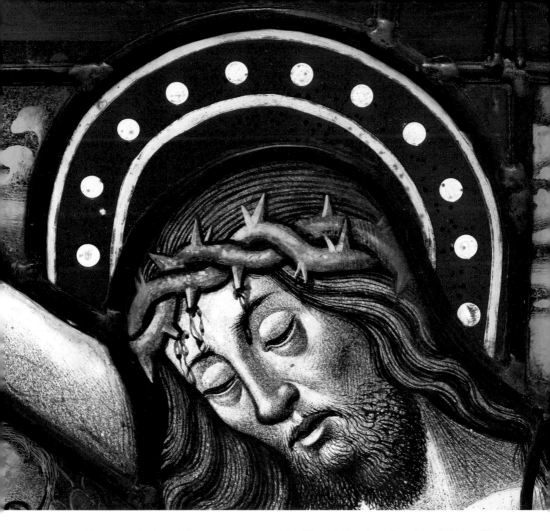

Two panels dated about 1500–1510, *The Crucifixion* (see fig. 7) and *Saint Christopher and a Donor* (see fig. 41), show the results of this technique in large-scale works. The halos around the heads of Christ (fig. 14), the Virgin Mary, and John in *The Crucifixion*, as well as the brilliant rays around the head of the infant Christ being carried by Saint Christopher (see fig. 41 and p. 86, detail), are executed in flashed and abraded red glass, which was then treated with silver stain to provide both white and yellow accents. Silver stain also accents Christ's crown of thorns in *The Crucifixion* panel.

Producing a Window from Start to Finish

The creation of a stained glass window truly begins with an artist's sketch, known in medieval times as the *vidimus*, Latin for "we have seen." A late-sixteenth-century pen-and-ink drawing for a window by the Swiss artist Hans

Jacob Plepp, for example, shows the main elements of the design only on one half of the drawing (fig. 15). There was no need to repeat all the details of the elaborate architectural decorations: the column on the left in this drawing, for example, could easily be copied to the column on the right. The agreed-upon text appears in the inscription panel, but not the calligraphy, which would be rendered by the artist at a later stage, when painting the glass. The allegorical virtues—*Fides* (Faith) and *Spes* (Hope)—are named here, not drawn. Very likely, the client had been shown other drawings of these stock figures and had approved of them. The size of this sketch is typical for Swiss panels of this time—42.4 × 29.5 cm (16 ¹¹⁄₁₆ × 11 ⅝ inches)—so presumably it represents a one-to-one ratio. For larger panels, the first sketch would be smaller and then enlarged to a full-size rendering, called a cartoon. Artisans used the cartoon to draw the exact sizes and shapes making up the separate pieces of a stained glass panel. The different pieces were then cut and painted following the patterns indicated on the cartoon.

Fig. 16 · Detail of the sorting marks on the back of the shield from *Heraldic Roundel with the Arms of Ebra* (fig. 34)

In the early Middle Ages, before paper was readily available, cartoons were drawn on whitewashed tabletops that would then be used for cutting and painting the glass as well as for assembling the finished window. Remarkably, one such medieval cartoon, adhered to a table—from Gerona, Spain—is extant, surviving only because it was reused as part of a cabinet; two fourteenth-century windows constructed on its pattern are found in Gerona's cathedral. In the fifteenth century, the Italian artist Cennino Cennini documented the use of paper cartoons, urging the gluing together of as many sheets as the designer needed.

After the stained glass segments were painted, they were fired in a kiln at approximately 1250°F (680°C). As the glass-flux softened and the surface of the glass sheet became tacky, the two elements fused to create a permanent bond.

Although lacking instruments to measure temperature, early glassworkers responsible for loading and operating the kiln developed a remarkable sensitivity for determining effective firing times and degrees of heat. Theophilus, for example, recorded the possibility of leaving pots of molten glass in the kiln for different lengths of time in order to produce different colors. Given that the process was time consuming and demanded close supervision, the producers of stained glass wanted to maximize kiln usage.

Generally, several pieces, even from different windows, could be stacked in the kiln and fired at the same time. Sorting marks were used to identify and assemble panels after firing a number of pieces. A brilliantly executed heraldic panel in the Getty collection illustrating the arms of Ebra, produced in the late fifteenth century by the Hirsvogel—a Nuremberg family of stained glass artisans—bears sorting marks in the form of a number 6 scratched into the reverse side of each segment of glass (fig. 16). The trained specialists in the Hirsvogel workshop could fabricate windows on the basis of a designer's model, often including the selection of colors.

The fired sections were joined together with malleable H-shaped strips of lead called cames. Medieval cames were cast in molds, while modern ones are extruded from a mill. The relatively soft alloy allows the cames to be bent around the segments of glass with minimal pressure; it also allows some flexibility, so that minor shocks are distributed throughout the window, preventing cracks in the glass. Depending on their alloy, size, and the variable stresses they undergo in place, lead cames can last hundreds of years. The rare medieval cames that have survived since the fourteenth and fifteenth centuries are of considerable historical importance and merit the same care and respect as the historic glass they frame.

Cames are soldered at their joints and generally caulked to make them watertight, although medieval leads, being thicker, often were not caulked. These leaded sections are set into an iron framework, called an armature, and then fitted into the stone or wood of the window opening. In addition, horizontal support bars are placed into the interior molding frames to help stabilize the window against wind stress.

Notes
1 John G. Hawthorne and Cyril Stanley Smith, eds. *Theophilus on Divers Arts: The Foremost Medieval Treatise on Painting, Glassmaking, and Metalwork* (New York, 1979), 64.

2 Ibid.

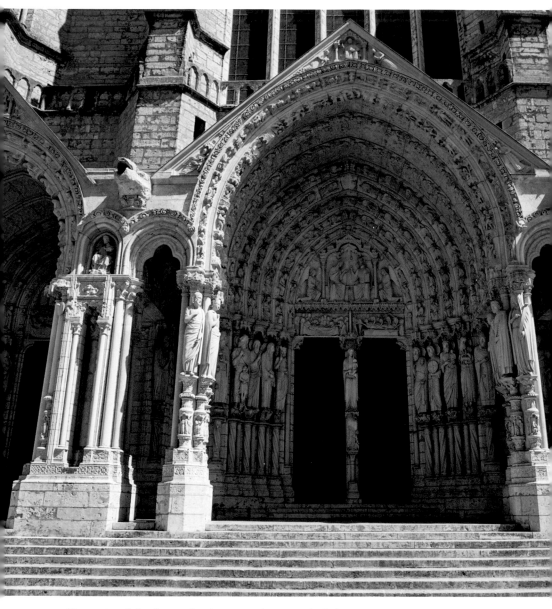

Fig. 17 · North facade, completed ca. 1230, Chartres Cathedral, France

Architectural Function of Stained Glass

In the Middle Ages and the Renaissance, many public buildings conveyed grand narrative themes, through sculptural elements on the exterior and glass and wall painting in the interior. Allied to the art of Gothic construction, the figural window dominated image making for four centuries, emerging again in the nineteenth century with the revival of the Gothic style. Throughout history, architectural monuments have represented a fusion of image, space, color, light, and materials; and, of particular relevance here, they reveal how designers and artisans sculpted interior spaces via the medium of stained glass.

Cathedrals

The great cathedrals of the Western world have long been recognized as the quintessential repository for stained glass. These vast, ornate edifices often contain a variety of aesthetic styles and subjects, and given their long histories, they reflect shifts in religious sensibilities as well as proclaiming the social status of those who commissioned the windows. The success of these windows has often been attributed to a unique cooperation between arts and architecture. Every decision regarding their creation was made with an understanding of both purpose and audience. Stained glass cathedral windows should be seen not in mere decorative terms but as artistic expressions vital to the societies that produced them.

The three components of these buildings—architecture, stained glass, and sculpture—were forged into a single unified whole. Within each church, sculpted or painted images declared the creed of the makers while designating the hierarchy of space. In the ideal building campaign, windows were planned from the start and produced as each section of the building neared completion. Like the sculpture, they were part of the architectural ensemble, not added simply to embellish the building.

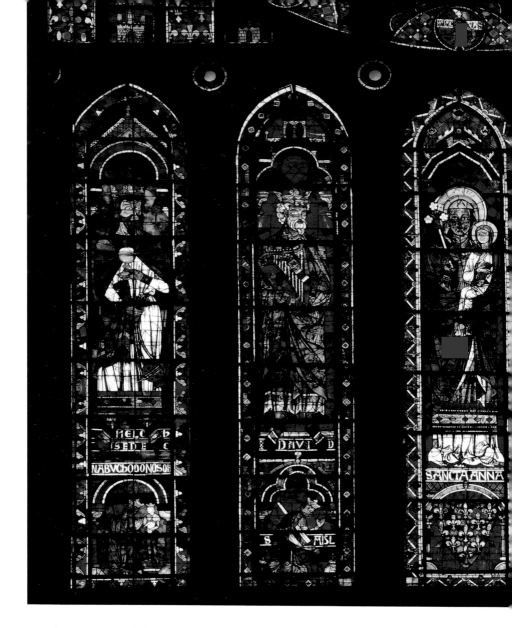

The integrity of the plan can be seen in the sculpture and glass of the north facade of Chartres Cathedral (fig. 17). Completed about 1230, this part of the structure consists of three deeply recessed portals, each framing doors that lead into the cathedral. The narrative theme is the Old Testament prefiguring the New. The central sculptural element is the image of Saint Anne, who holds her infant daughter, Mary, in her arms. The impetus for such imagery stemmed from the cathedral's acquisition of the relic of the head of Saint Anne, taken from Constantinople in 1204—throughout the Middle Ages the display of relics functioned

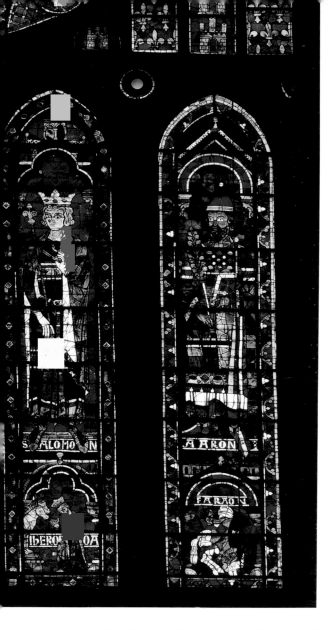

Fig. 18
North transept lancet
windows, ca. 1235, Chartres
Cathedral, France

as a major attraction for churchgoers. Like the sculpture, the windows--installed
about 1235—proclaim the transition from the Old Testament to the New. A rose
window surmounts a series of five lancets showing the Israelite kings David and
Solomon and the priests Melchisedek and Aaron (fig. 18). They flank Saint Anne,
who, as on the exterior, holds the infant Mary. Significantly, this display of hered-
itary power was sponsored by France's royal house, most likely by the queen,
Blanche of Castile. The castles of Castile and the fleur-de-lis of France are on
either side of the rose. Saint Anne stands above a fleur-de-lis shield.

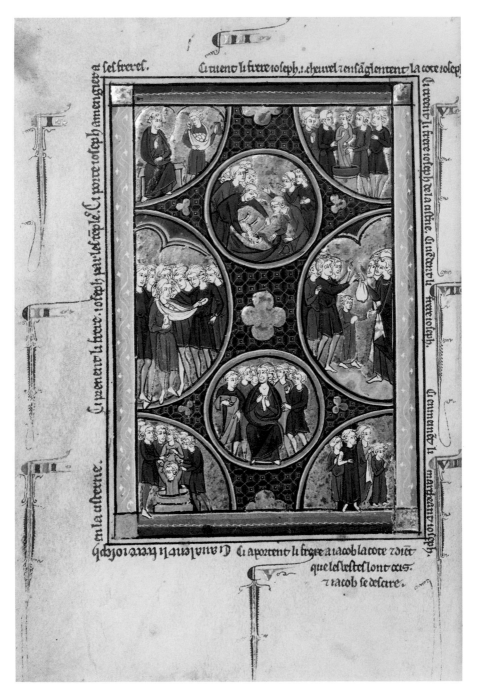

Fig. 19 · *Scenes from the Life of Joseph* from the Wenceslaus Psalter, French (Paris), ca. 1250–60. Tempera colors, gold leaf, and ink on parchment, 19.2 × 13.3 cm (7 9/16 × 5 ¼ in.). JPGM, Ludwig VIII 4, fol. 15, 83.MK.95.15v

Stained glass, considered a precious object, also was linked in the twelfth and thirteenth centuries to the aesthetics of valued jewels and metals and to the biblical text of the book of Revelation. The Heavenly City (Jerusalem) as described in Revelations was the core reference for church construction: "[T]he building of the wall thereof was of jasper stone: but the city itself pure gold, like to clear glass. And the foundations of the wall of the city were adorned with all manner of precious stones" (Rev. 21:18–19). Durandus, the thirteenth-century bishop of Mende (southern France), developed an allegorical meaning for elements of the physical structure: "For the material church wherein the people assemble to praise God symbolizes that Holy Church which is built in heaven of living stones" (Durandus I:ix). "The windows of the church which are made of transparent glass are the Sacred Scriptures which keep away the wind and the rain, . . . but allow the light of the True Sun, that is God, into the hearts of the faithful" (Durandus I:xxiv)[author translations]. It is logical, then, to associate such descriptions with monumental houses of worship and to regard the windows as representing the gems that adorned the Heavenly City. The very splendor of the cathedrals was justified by allusion to Solomon's Temple, as described by Suger, the twelfth-century abbot of Saint Denis, when explaining his own building programs. The buildings were meant to represent the Heavenly Jerusalem, where Christ would welcome the faithful into God's realm.

In twelfth-century Europe, cathedral walls were thick, and most of the windows were simply arched openings. Early thirteenth-century windows were larger, and, in the cathedrals of Chartres and Canterbury, stained glass dominated the interiors. At Chartres, for example, individual figures appear in the upper windows, while a narrative of the lives of saints and stories from the Bible characterizes the lower windows in the nave and the ambulatory. The most common format showed multiple scenes set in complex medallion patterns, typically containing an average of some thirty-six scenes in twelve registers, organized in geometric shapes, such as circles, quatrefoils, petals, or canted squares (see fig. 20).

So pervasive was this approach that even manuscript illumination adopted medallion formats, as shown in a Parisian manuscript from about 1250–60 of the life of Joseph, from the book of Genesis (fig. 19). Joseph was the subject of one of the earliest windows at Chartres, installed about 1205–15 (fig. 20). Both manuscript and window used a medallion format with contrasting blue and red. As was usual throughout the Middle Ages, the scenes were rendered on a flat plane rather than three-dimensionally. The setting was evoked by a schematic allusion to a door or a ground line. Figures were silhouetted against uniform grounds, and

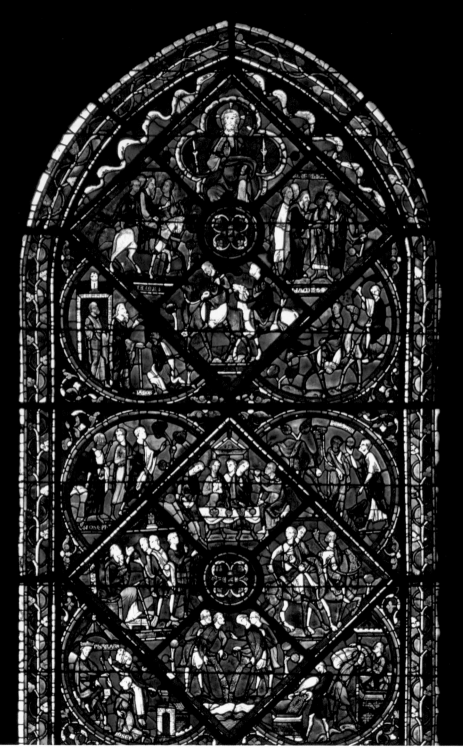

Fig. 20 · Top section of the Joseph Window, ca. 1205–15, Chartres Cathedral, France

the stories were told with gesture and symbol. Instantly recognizable in the manuscript is Joseph being lowered into the pit (bottom left) and Joseph's brothers selling him while a bag of money changes hands (middle right). In the upper portion of the window, images of camels signify the exotic locale of Egypt. According to the English art historian Peter Brieger:

> [I]f the illuminators used the same patterns and model books, it is not simply because they followed the example of the window designers, but because the geometric order establishing sequences and relations was the natural and logical as well as the aesthetically appropriate one to be used by artists, who were taught to visualize human and divine relations in terms of eternal validity, satisfying reason and faith and independent of change in time and space.[1]

The colors in figural windows were dense, but they invariably alternated with non-figural grisaille to maximize light. Grisaille glass windows were composed primarily of uncolored glass, although narrow bands of color frequently accented the patterns. The overall design of the window as well as the detail on the painted segments could be geometric or floral. Skilled artists meticulously executed these windows, modulating light by means of delicate brushwork. The windows were not inexpensive, for the glass itself, the lead cames, and the metal armature for the windows were costly items in preindustrial times.

As the Gothic style matured during the thirteenth century, windows became narrower and more attenuated, as evidenced by the choir of Sées cathedral in Normandy, France, built ca. 1270–80 (fig. 21). As builders were able to lighten the fabric of walls and increase height through external support systems, so masonry walls were increasingly given over to stained glass, and the structure appeared to dematerialize in vertical fields of light and color. With the end of the great age of cathedrals at the beginning of the fourteenth century, houses of worship were no longer built on the national but rather on the local and regional level. As a consequence, the scale of the architecture, and necessarily that of the glazing programs, diminished.

In addition, the window style changed radically. The medallion window of the early thirteenth century, with its dense colors and geometric framing of episodes, gave way to a sequential format that read like a book—an increasing number of the laity could read, and they carried private books of devotion with them into places of worship. Windows in grisaille, giving more light, were more frequent within the

schema of the glazing program, and frequently even figural work appeared between upper and lower zones of uncolored glass. Within such areas, artists often used a format showing standing figures under a canopy, which was represented with increasing three-dimensional realism. This format came to dominate the production of windows for several centuries, as exemplified by *The Crucifixion* (see fig. 7) and *Saint Christopher and a Donor* (see fig. 41).

The development of stained glass as a major art form in the Middle Ages depended on the needs of a powerful client, the Church. Cathedrals were, in effect, corporate enterprises, the seat of the bishop, with ecclesiastic and frequently secular powers that affected those who lived in the diocese. Members of the clergy were the primary patrons, but they designed programs for a wide constituency, including powerful allies such as those who donated generously on their behalf, but also pilgrims and parishioners. The commissioners of these labor- and materials-intensive works of art saw themselves as contributing to an eternal enterprise. Henry VII regarded his gifts of vestments to Westminster Abbey before 1505, for example, as a perpetual legacy, "while the world shall endure."

Monastic Foundations

Monastic life, in the sense of living apart from society, began as a practice of hermits, located in areas of the eastern Mediterranean in the late third to early fourth centuries. As they began to attract followers, they developed modified systems conducive for a communal life. In such societies, reciprocity was the bond of order, and religious practice was viewed as an accepted element of exchange. Prayers were necessary, not simply for rituals associated with births, deaths, and marriages but also for daily petitions for good health or even favorable weather; in times of stress, prayers were offered for victory in battle or alleviation of pestilence. Those who could devote their lives exclusively to prayer were believed to be more effective in their petitions, and thus could speak to God for others. Eventually, monasteries became urban institutions, wielding considerable economic, social, and intellectual force.

The power of these religious institutions rested in their close association with the nobility; abbots, abbesses, and bishops, who possessed land and thus wielded considerable influence, invariably came from the upper class. Hedwig of Silesia,

◁ **Fig. 21** · Choir triforium and clerestory windows, 1270–80, Sées Cathedral, France

◁ **Fig. 22**
Court workshop of Duke
Ludwig I of Liegnitz and
Brieg (Polish, 1364–98),
*Saint Hedwig of Silesia with
Duke Ludwig I of Liegnitz
and Brieg and Duchess
Agnes* from The Life of the
Blessed Hedwig, Silesian,
1353. Tempera colors,
colored washes, and ink
on parchment, 34.1 × 24.8
cm (13 7/16 × 9 3/4 in.). JPGM,
Ms. Ludwig XI 7, fol. 12v,
83.MN.126.12V

Fig. 23 ▷
Saint Bernard, German
(Cologne?), ca. 1500.
Colorless glass, vitreous
paint, and silver stain,
diam.: 23.2 cm (9 1/8 in.).
JPGM, 2003.55

for example, whose life is richly illustrated in a landmark manuscript (fig. 22),
founded the Cistercian abbey of Trzebnica, where her daughter became abbess in
1218. Hedwig had married Duke Henry I, a nobleman of Silesia (now in present-day
Poland), and after his death retired to the abbey, ultimately being canonized as a
saint in 1267. Here she is depicted with the commissioners of the manuscript,
Hedwig's descendant, Ludwig I of Liegnitz, and his wife, Agnes of Glogau.

Although the cloistered areas of monasteries were forbidden to all except the
professed, their churches were often designed to allow veneration of shrines and

relics for noble patrons as well as pilgrims. Important patrons vied to be buried in chapels associated with monasteries, a strategy perhaps best exemplified by the late-fourteenth-century donations made to the Chartreuse de Champmol just outside Dijon by Philip the Bold, Duke of Burgundy. Philip's tomb was one of the costliest and most artistically significant of the funerary monuments of the Middle Ages. However, not only wealthy patrons but also monks commissioned artwork to show their devotion, often by associating themselves with images of revered religious leaders. One such image is that of Saint Bernard of Clairvaux, on a small roundel showing the saint in a rural setting (fig. 23). Bernard was one of the luminaries of the Cistercian order (named after its founding at Cîteaux in Burgundy). By the time of Bernard's death in 1153, the order had become one of the most influential of its time, with 350 monasteries across Europe.

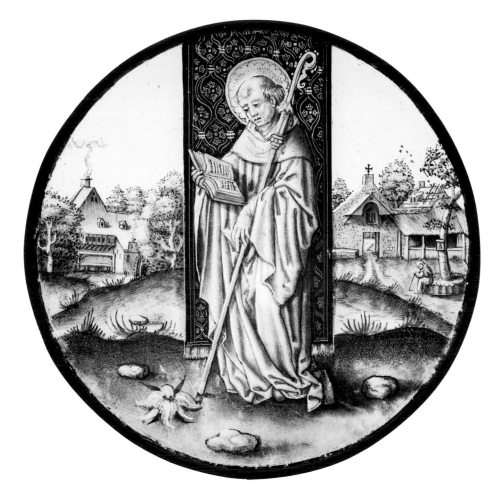

After a disastrous fire at Klosterneuburg in 1330—one of the most prestigious monastic sites in Europe, located just north of Vienna—the prior Stephen of Sierndorf commissioned the rebuilding that included at least one set of figural windows in fourteen openings (fig. 24). *The Virgin and Child* panel (fig. 25) was originally in the upper tracery of a window above the images of the *Finding of the Boy Jesus in the Temple* and *Christ Healing the Lepers*. A wealthy institution, founded by the Margrave Leopold III, the monastery also houses the series of enamel panels known as the Klosterneuburg Altarpiece, completed in 1181 by Nicholas of Verdun. The panels are developed around the medieval typological order, which pairs images from the Old and New Testaments. This system is repeated in the cloister glazing.

The cloister is now devoid of its original glass; about one-third of the series, however, has been reassembled into window openings of the monastery's chapel. In 1749 the antiquarian Benedict Prill recorded the state of the windows in an illustrated manuscript; although too few pieces remain to reconstruct the cloister's original layout with certainty, the windows evidently reflect a local tradition. The composition of all five extant Old Testament narrative panels is based on the enamel plaques of the great altarpiece: *Birth of Isaac, Circumcision of Isaac* (mod-

eled after the *Circumcision of Samson*), *Moses Crossing the Red Sea*, *Moses Return-ing to Egypt with His Wife and Son*, and the *Sacrifice of Melchisedek*. The cloister also repeated the device of the framed medallion with surrounding inscription.

Scholars have suggested a stylistic affinity between these windows and manu-scripts also produced at Klosterneuburg under the authority of Stephen of Siern-dorf. The painting in *The Virgin and Child* (see fig. 25) shows artistic confidence and is also recognizable in other panels in the cloister, such as the head of John the Evangelist from a tracery light of the *Death of the Virgin*. This confidence, expressed with clarity of form and reliance on trace outline, is found in other Austrian glazing programs of the time, such as that of Heiligenkreuz Abbey in the Vienna Woods.

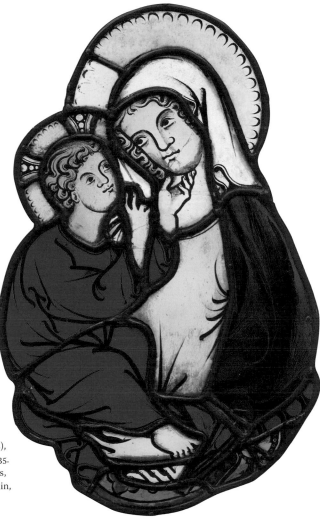

◁ **Fig. 24**
Cloister, 1330–45,
Klosterneuburg
Monastery, Austria

Fig. 25 ▷
Master of Klosterneuburg
(Austrian, active early 1300s),
The Virgin and Child, ca. 1335.
Pot-metal and colorless glass,
vitreous paint, and silver stain,
35.9 × 20.3 cm (14 ⅛ × 8 in.).
JPGM, 2003.32

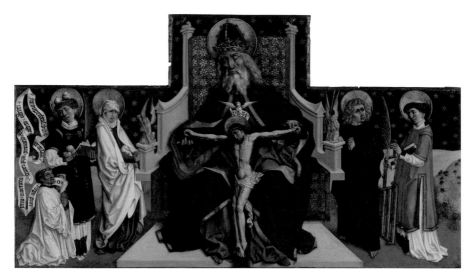

Fig. 26 · Workshop of Peter Hemmel von Andlau (German, active in Strasbourg ca. 1420/1425–
after 1501), *The Trinity with the Virgin, Saints John the Evangelist, Stephen and Lawrence
and a Donor*, 1479. Oil on panel, 79.8 × 140.2 cm (31 7/16 × 55 3/16 in.). JPGM, 2012.22

Religious patrons, such as Stephen of Sierndorf, were keen not only to fund
but also to sponsor images of themselves as patrons. Representations extended
across all media, including oil panels such as the highly significant altarpiece *The
Trinity with the Virgin, Saints John the Evangelist, Stephen and Lawrence and a
Donor*, from 1479 (fig. 26). Here, the artist included the portrait of an unidenti-
fied clerical donor of considerable wealth, seen kneeling down on the left with a
banderole carrying his petitions. Looking down protectively at the donor is Saint
Stephen, martyred in Jerusalem, and on the far right is his counterpart from Rome,
Saint Lawrence. Both Stephen and Lawrence are dressed in deacon's vestments. In
the center, the Holy Trinity is presented as the *Gnadenstuhl* (Throne of Mercy).
God the Father holds his crucified Son in his arms, while the Dove of the Holy Spirit
hovers between them. Close to the Trinity on the left stands the Virgin Mary, and on
the right is John the Evangelist. The painting is attributed to the workshop of Peter
Hemmel von Andlau, an artist/designer well known for his work in stained glass.

Similarly, in a pair of French stained glass panels dated to about 1510–15, a lay
donor appears with two monastic saints: Fiacre, a seventh-century Irish monk
who evangelized the area around Meaux, in the Île-de-France near Paris; and an
unidentified Benedictine abbot, possibly Benedict himself (fig. 27). The abbot, at
right, holds a crosier, a staff resembling a shepherd's crook that symbolizes the

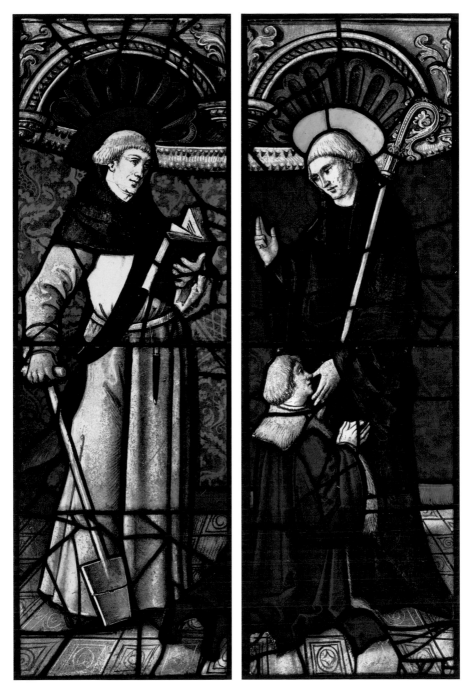

Fig. 27 · *Saint Fiacre* and *Benedictine Abbot Saint with a Donor*, French (Lorraine), ca. 1510–15. Pot-metal and colorless glass, vitreous paint, and silver stain, each 127.8 × 40.6 cm (50 5/16 × 16 in.). JPGM, 2003.60.1, .2

authority of a bishop or abbot over his flock. Saint Fiacre, on the left, holds a gardening spade, a symbol of his patronage of agriculture. The donor wears a fur-lined robe—a mark of privileged status—and kneels before the abbot, who lifts his right hand in blessing. The conch-shaped niches and cloth of honor behind the saints indicate up-to-date motifs that parallel those common to paintings of the same era. Well into the Renaissance, members of the laity, such as the wealthy donor depicted here, continued making gifts in exchange for prayers of intercession. The directors of these institutions, both men and women, invariably were from the elite classes, thus ensuring social cohesion.

Parish Churches

Imagery designed for the parish church demonstrates the artistic and devotional sensibilities of a new class of patron. Economically and politically, the rise of a merchant class, particularly in the fifteenth and sixteenth centuries, transformed

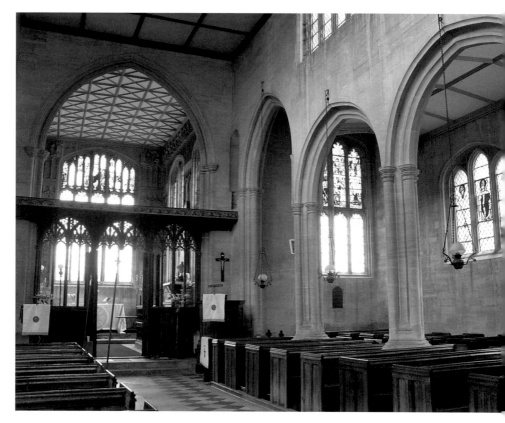

Fig. 28 · Nave and chancel, 1493, All Saints church, Hillesden, England

artistic patronage. The age of great cathedrals was over, and the focus shifted to building parish churches, many of which achieved impressive size. No longer did ecclesiastical taste dictate the appearance of church buildings and their decoration. Influential families added private chapels to already established buildings in order to commemorate their own members. Private residences, although not changing in structure, received new kinds of windows that reflected contemporary subject matter.

The parish church was the most important communal building of the village, the site of legal, social, and artistic as well as religious activities (fig. 28). Even in cities boasting a cathedral and several churches built by the religious orders, parish churches were necessary to serve the laity. These churches frequently depended on the support of ordinary local lay folk—farmers, craftspeople, and merchants. By the mid-fifteenth century, most parish churches exhibited similar features: one tower (almost always at the west end), an entrance porch, and a tall, timber-roofed nave with aisles and clerestory windows. A screen crowned by a freestanding cross (called a rood screen) defined the chancel, which was often at a lower elevation and with a distinctive roof. Additional interior divisions appeared as chapels, sometimes to the left and right of the chancel, and sometimes set in the aisles. Stained glass adorned the many windows, most often portraying standing figures or scenes framed by borders drawn to look like architecture and allowing considerable light into the interior space.

In parish churches, stained glass imagery was far less likely to represent abstract theological principles. Instead, it reflected what was important for the laity: a direct, emotional link to God and the saints. No matter how complex a program might be in its full elaboration, artists consistently sought to appeal to the hearts and minds of the unsophisticated viewer with images that elicited empathy. One way was to depict Christ as a brother, able to experience the same sorrows as the viewer. Earlier, artistic renderings of the triumph of Christ had prevailed. In the basilica of St. Peter at Poitiers, for example, a twelfth-century window, probably given by Henry II and Eleanor of Aquitaine, shows the Crucifixion and Ascension. Christ is not dead, and his arms are open in a gesture of ecumenical embrace of the world. The Virgin Mary and John are witnesses rather than performers in the drama.

But back in the thirteenth century a different piety had developed, one focused on Christ's suffering and human nature instead of his divinity. The new preaching orders encouraged this trend. Chief among them were the Franciscans, established by Saint Francis in 1209 and granted papal confirmation in 1223. The Franciscans

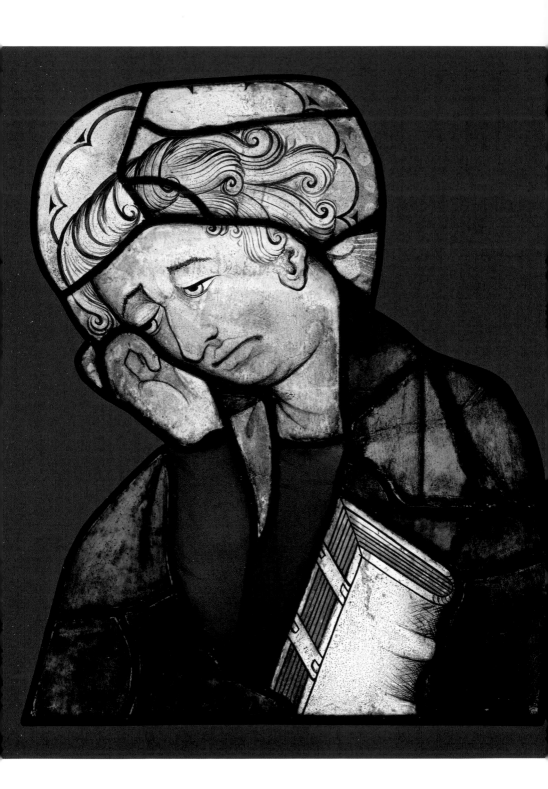

ministered to lay communities, especially those in the burgeoning cities. Stories of
Francis described the saint's intense empathy for Christ's humanity; in an ecstatic
vision, Francis was believed to have actually received the marks of Christ's wounds,
the stigmata, on his own body.

Such passionate emotion appears in the German panel fragment showing Saint
John, dated about 1420 (fig. 29). The multiple lines delineating the furrowed brow
and the simple outlines of the face and downcast eyes convey a sense of unfath-
omable loss. John, the apostle "whom Jesus loved" (John 20:2), brings his clenched
hand to his face as if his head has become too heavy to support itself. This depiction
of Saint John, with his fair complexion and golden hair, is similar to that in an Aus-
trian missal from the same era in which the saint is likewise dressed in green and
sports luxuriant curls (fig. 30).

Often the religious figures depicted in parish churches appealed to the faith-
ful because the artist selected physiognomic types that were familiar to the local
population. A small image of an apostle (probably Saint Philip) dating to about
1460–70 from the Rhineland is typical of this kind of imagery popular in parish
churches (fig. 31). We can imagine finding similar facial types in the residents of

◁ **Fig. 31**
The Apostle Philip, German
(Cologne?), ca. 1460–70.
Pot-metal and colorless glass,
vitreous paint, and silver stain,
47 × 22.2 cm (18½ × 8¾ in.).
JPGM, 2003.45.2

Fig. 32 ▷
Detail of the arms of the
Dreux-Bretagne family in the
south transept lancet windows,
1221–30, Chartres Cathedral,
France

Rhenish towns and environs. The panel is composed of uncolored glass tinted with silver stain to outline the borders of Philip's robe and halo as well as the ground on which he stands. His original context is unknown, as the red glass now surrounding the figure is a later restoration. In general, apostles can be identified by distinct symbols, the most common being the keys that Peter carried, illustrating Christ's statement that he would give Peter the keys of the kingdom of heaven (Matthew 16:19). Saint Thomas became associated with a spear, the instrument of his martyrdom in India. Philip is usually portrayed with a cross but cannot always be identified by it, because other saints may also carry the same symbol.

Heraldic Windows

In the Middle Ages, family lineage was communicated by means of heraldry, the public display of insignia representative of the donor. Heraldic display emerged in the thirteenth century with placements of the shields of prominent families, such as the distinct gold-and-blue (*or* and *azur* in the heraldic nomenclature of Old French) checker pattern of the arms of Dreux-Bretagne that appears in the south-transept lancet windows at Chartres Cathedral, installed in the 1220s. The heraldic-clad female donor is portrayed kneeling in the left lancet, her male counterpart kneels in the right lancet (not shown here), while the shield alone appears in the central lancet (fig. 32).

As societies became more diversified, many more individuals developed coats of arms. By the fifteenth century, lesser nobility and even local citizens in these predominantly mercantile societies boasted heraldic badges. Examples include the arms of the Eberler family of Basel (see fig. 45) and those of Fridolin Kleger, who held the post of bailiff of the Swiss Gaster region in the mid-sixteenth century (see fig. 48).

Because the goal of the design was instant recognition, heraldry depended upon clearly defined formats, a limited color range, and high contrasts in value and hue. The blazon of Cardinal Albrecht von Brandenburg, produced about 1525–30 as the frontispiece to a prayer book, sets the light-colored shield against a rich blue background (fig. 33). The painted devices, in heraldic nomenclature, appear as *gules* (red), *sable* (black), *or* (yellow) and *vert* (green) against *argent* (white). The cardinal's red hat, with its complex tassels, frames the shield. The same visual

Fig. 33 · Simon Bening (Flemish, ca. 1483–1561), *Blazon of Cardinal Albrecht von Brandenburg* from
the Prayer Book of Cardinal Albrecht von Brandenburg, Bruges, ca. 1525–30. Tempera colors,
gold paint, and gold leaf on parchment, 16.8 × 11.4 cm (6⅝ × 4½ in.). JPGM, Ms. Ludwig IX 19,
fol. 1v, 83.ML.115.1v

Fig. 34 · *Heraldic Roundel with the Arms of Ebra*, German (Nuremberg), ca. 1480–90. Pot-metal, flashed, and colorless glass, vitreous paint, and silver stain, diam.: 25.7 cm (10 ⅛ in.). JPGM, 2003.57

clarity distinguishes the *Heraldic Roundel with the Arms of Ebra* from Nuremberg, dated about 1480–90 (fig. 34; see also fig. 16, detail). The ladder is shaded to create an eye-catching three-dimensionality that harmonizes with the spatial power of the volumetric mantling.

Heraldry was not only confined to religious buildings, as it became customary to embellish domestic settings also with heraldic glass. For example, in the great hall of Ockwells Manor in Berkshire, England, built about 1460, densely colored shields and clear grisaille with inscriptions combined to achieve both definition and illumination; within the lattice or bull's-eye of uncolored glass, the heraldic shield glowed like a colored gem. Heraldry became the dominant art of many Protestant countries, exploiting the Renaissance love of ornament to create frames of

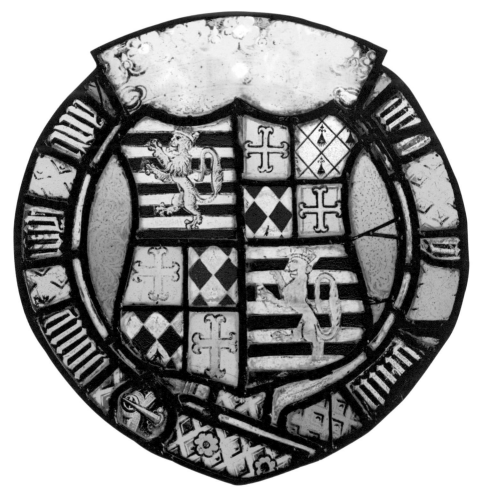

Fig. 35 · *Heraldic Panel with the Arms of Charles Brandon*, English (East Anglia?),
ca. 1520–30. Pot-metal and colorless glass, vitreous paint, and silver stain,
diam.: 43 cm (16 15/16 in.). JPGM, 2003.65.1

dramatic impact. Invariably retrospective display allowed the creation of a desired lineage and august family history. A case in point was that of Sir Edward Seymour, Lord Protector during the reign of Edward VI and sympathetic to commoners and liberal religion. Executed on an admittedly weak charge in 1552, he was honored almost fifty years later, when his arms were incorporated among the individuals heraldically depicted in windows of the Elizabethan Warkworth Manor, Northamptonshire. The manor house was dismantled in 1806, and the Detroit Institute of Arts acquired heraldic panels from the site.

In England, a prestigious subset of heraldic representation was a shield encircled by the Order of the Garter—the oldest and most illustrious of that country's orders of knighthood, founded by Edward III, most probably between 1346 and 1348. The arms of Charles Brandon, First Duke of Suffolk, belonged to an influential individual who was a childhood companion to Henry VIII (fig. 35). Brandon was also the husband of Mary Tudor—the king's sister—as well as a military commander and a diplomat. The upper part of the shield includes a crown, most likely from another panel in the series (a type of insertion generally called a stopgap), installed in reverse. The border is the garter with its traditional inscription: *Honi soit qui mal y pense* (Let him be ashamed who thinks ill). Such imagery was all-important in proclaiming lineage and access to property rights.

Buildings "spoke" through their imagery, and before the seventeenth century much of the language was carried by the stained glass. At all times, windows entailed a significant allocation of expensive materials and a complex production. What now might seem merely decorative, such as a family shield, was then a vital aspect of statecraft, proclaiming social rank and its privileges. Just as the windows of Gothic cathedrals revealed clerical power and those of parish churches addressed affective piety, heraldic glass communicated social status.

Notes
1 Peter Brieger, *English Art, 1216–1307* (Oxford, 1957), 95.

Artists and Patrons

As expressed in the late-fourteenth-century poem *Piers the Plowman's Crede*, stained glass was a typical feature in medieval buildings. Whether cathedral, monastic foundation, parish church, or even secular building, embellishment was achieved with painted walls and glazed windows "glowing as the sun."

> A chirche and a chapaile [chapter house] with chambers alofte,
> With wide windowes ywrought and walles well heye
> That mote bene portreid and paynt and pulched ful clene,
> With gaie glittering glas, glowyng as the sonne.[1]

William Langland, the presumed author, proceeds to condemn the religious orders that were avidly seeking money to decorate churches and promising heavenly rewards for pious acts of giving. Stained glass was indeed a costly medium. Although brilliant and highly permanent, it demanded expenditure for the production, the design and execution in paint, and then the setting in lead, solder, and iron framework. The whole process required artists and patrons to work closely together in all aspects of the planning, production, and financing. The commissioning patron needed the artist for the assertion of social status as much as the artist needed the patron to have the opportunity to create.

Thus the selection of the essential aesthetic elements of the design was a highly controlled process, as reflected in the 1447 commission for the windows of the Beauchamp chapel at Warwick.[2] The contract between the executors of the Earl of Warwick and John Prudde of Westminster, the "glasier," demanded that he execute

> all the windows in the new chappell in Warwick . . . with the best, cleanest, and strongest glasse of beyond the seas that may be had in England, and of the finest colours: of blew, yellow, red, purpure, sanguine, and violet, and of all other colours that shall be most necessary to make rich and embellish the matters, images, and stories, that shall be delivered and appoynted by the said executors by patterns in paper, afterwards to be newly traced and pictured by another painter in rich colour, at the charges of the said glasier. All which proportions the said John Prudde must make perfectly to fine, glase, eneylin it and finely and strongly set it in lead and solder it as well as any glasse is in England.[3]

The preference for glass produced outside England indicates the existence of robust international trade at the time. The parties commissioning the chapel

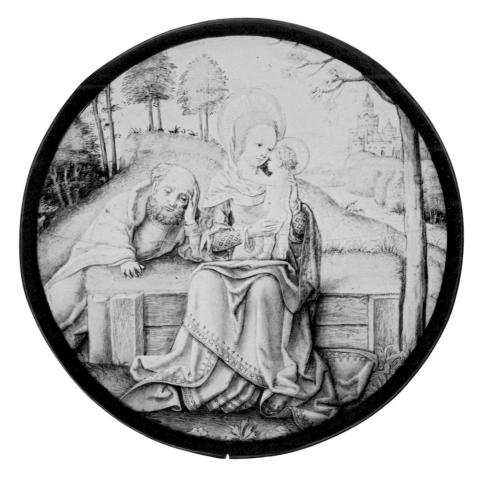

clearly stipulated that Prudde, the head of the workshop, deliver paper patterns for approval before the windows were executed. Such a demand was discussed in the 1526 contract for King's College Chapel in Cambridge and was probably referred to as what "good and true patrons . . . called a vidimus".[4] The patron for King's College was Henry VIII. Even if the contract for Warwick was referring to full-size drawings—the step beyond the *vidimus*—the language makes it clear that one artist planned the window, and then it was "traced and pictured by another painter in rich color." That is, after the paper pattern was approved, another artist in the workshop would make full-scale drawings to be used as the guide for cutting the pieces of glass and for painting them.

To execute specific features in a stained glass window—a face, for instance, or sections of a robe—vitreous paint consisting of finely ground glass and iron or copper oxide mixed with a liquid was applied to the glass with a brush. The painted

Fig. 36 · *Rest on the Flight into Egypt*, South Netherlandish (Bruges?), ca. 1510. Colorless glass, vitreous paint, and silver stain, diam.: 22 cm (8 ¹¹⁄₁₆ in.). JPGM, 2003.56

Fig. 37 ▷
The Madonna of Humility, Netherlandish, ca. 1450–70, after Robert Campin (Netherlandish, ca. 1375–1444). Oil on panel, 48.6 × 37.8 cm (19 ⅛ × 14 ⅞ in.). JPGM, 77.PB.28

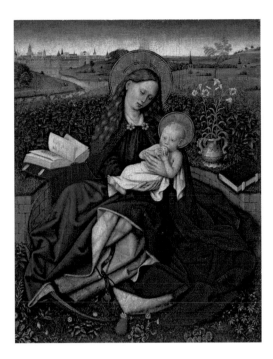

glass was then fired ("eneylin it" in the contract) so the ground glass in the paint fused with the surface to yield a lasting image. The paint, which often was applied to the back of the glass as well, could be simply an application of trace (which is a thickly painted line, usually a contour) to indicate features. Three-dimensional effects could be created by applying an even layer of paint, which usually provides a halftone shading, called a mat, and removing portions of the mat with a brush, a stick, or even a needle to create fine details.

The Popular Image

In the Middle Ages, a shared culture of biblical subjects, saints' legends, and liturgical ritual was the basis for much stained glass imagery, which frequently depicted how the life of the common person intersected with that of Jesus. The theme of the infancy of Christ, briefly narrated in the Gospels, was augmented by accounts that soon became accepted as biblical truth. Long cycles—for example, Giotto's series of images for the Scrovegni Chapel in Padua from 1305–1306—elaborated on those sources to represent in intimate detail the life of the Virgin and Jesus's early years.

According to the Gospel of Matthew (2:13), an angel told Joseph to take Mary and the child and flee to Egypt. No details are given, but pious imagination provided

Fig. 38
Christ on the Mount of Olives,
Netherlandish, ca. 1480–1500.
Colorless glass, vitreous paint,
and silver stain, diam.: 27.2 cm
(10 11/16 in.). JPGM, 2003.50

Fig. 39
Master of James IV of Scotland
(Flemish, before 1465–ca.
1541), detail of Death
attacking a rider, from
Deathbed Scene in the Spinola
Book of Hours, ca. 1510–20.
Tempera colors, gold, and ink
on parchment, leaf: 23.2 ×
16.7 cm (9 1/8 × 6 9/16 in.).
JPGM, 83.ML.114.184V

extensive narrative of the journey. The scene of rest on the flight into Egypt became one of the most popularly depicted moments from this episode. In this example (fig. 36), the holy family pauses in tranquil solitude, and Mary embraces the child, who stands on her lap; Joseph seems to function as a surrogate for the worshiper. His face is expressive, with hatch and crosshatch contour lines, the curly beard drawn with a layer of mid-tone shading, darker trace, and then circular strokes of the needle that reveal the white glass to define the highlights. His meditative stance, with his head cradled in his hand, hints at the medieval temperament of melancholia or introspection, suggesting that the vision of Christ is possible through thought. The elaborate use of silver stain in the patterns of Mary's dress and in the shading of the landscape emulates the rich modeling of such details in panel painting of the time. Its subject is also associated with contemporary paintings, such as *The Madonna of Humility* after Robert Campin from about 1450–70, (fig. 37). Here the Virgin is seated on the ground while in the roundel she is on a bench, but both their placement in a landscape and the intimacy of mother and child strike a similarly evocative note.

Roundels, pieces of uncolored glass painted in a manner similar to prints and drawings, became popular in the Renaissance. This form of stained glass was developed to serve a new wealthy mercantile class, and its scale suited the small windows in the urban townhouses they decorated. A roundel of about 1480–1500, *Christ on the Mount of Olives* (fig. 38), portrays the supremely human moment of Christ's last hours. The complexity of the scene helps the viewer to engage with

the story. The artist uses a warm red-brown paint for the rocks that silhouette Christ against a more neutral tone in the rest of the roundel. Skillful stickwork and needlework create visual interest and depth, enabling the viewer, who is meant to stand at close range, to engage with the characters. Christ prays while the apostles Peter, James, and John lie dozing in the foreground. Peter holds his sword, which anticipates the moment in the narrative when the apostle will cut off the ear of Malchus, the servant of the high priest Caiaphas (John 18:10). On the far left, Judas and the soldiers come through the garden gate, the betrayer recognizable by the bag of money in his right hand.

We find the same detailed storytelling in illuminated manuscripts of the time. An image from the Spinola Book of Hours, produced in Bruges and Ghent between 1510 and 1520 (fig. 39), shows Death assailing a rider. The dramatic foreshortening of the figure of the stricken man recalls the prone position of Peter as he sleeps while Jesus is at prayer.

A Netherlandish Crucifixion (fig. 40) created around the same time as the roundel in figure 38 is of a simpler composition. This work is more contemplative than narrative in nature. The function of the image here is to provide the faithful with a focus for prayer—as such it really is an interactive image. The artist configures a secluded scene to achieve a sense of intimacy. Two shades of silver stain—deep yellow for the cross and halos but lighter for the landscape—silhouette the three protagonists. The Virgin Mary and the Apostle John stand on a dark patch of ground, their bodies dominating the space of the roundel. Here the viewer is alone with Jesus and his two most beloved companions. The simple type of composition hearkens back to devotional images found in books of hours (prayer books containing selections from the psalms, hymns, and petitions to be recited at fixed times each day). In the prayer *Obsecro te* (I beseech you), for example, the reader commiserated with Mary's suffering as she contemplated Christ's death. Both John and Mary were invoked for their ability to bring the believer closer to Christ. In another popular prayer, *O Intemerata* (O Untouchable), also present in many books of hours, the worshipper petitions them both:

O jewels of the heavens, Mary and John, two divine lamps shining before God, dispel the gloom of my faults with your radiance. Be the two . . . in whom the only Son of God the Father, as the reward of your most sincere virginity, confirmed this as his special privilege, thus saying to you, as he was hanging on the cross, "Woman, behold thy son," and then to the other, "Behold thy mother." [5]

Fig. 40 · *The Crucifixion*, Netherlandish, ca. 1490–1500. Pot-metal and colorless glass, vitreous paint, and silver stain, diam.: 34.7 cm (13 ¹¹⁄₁₆ in.).JPGM, 2003.52

Devotion to Saints

A central medieval and Renaissance concept was that the dead and the living could communicate through prayer. It was a standard practice for individuals to adopt a patron saint, invariably based on their name given at baptism, and to endeavor to develop a personal relationship with that revered figure. With the rise of urban economies and greater influence of the laity, many more individuals claimed the privilege of representation. Often they selected images of their name saints or those for whom they felt a particular devotion.

Renaissance window programs frequently presented large-scale images of wealthy individuals protected by heavenly patrons. Easily recognizable by viewers, this conflation of influence testifies to a world of secular and religious reciprocity. Panel paintings as well as windows—sometimes even produced by the same designers—carried the same message of social status. Such representations appear in *The Crucifixion* (see fig. 7) and S*aint Christopher and a Donor* (fig. 41). Both show the donor's coat of arms, and in figure 41 the donor himself appears kneeling in front of Saint Christopher, who places his hand behind the donor's head in a gesture of protection. The rendering of the saint's garments with dramatic diagonals in deep pot-metal colors of red and blue against the light blue background sug-

gests the movement of Christopher's strides through the water. The Christ child riding on the saint's shoulders has a vividly striated halo and a golden orb—a symbol of kingship—which convey his divine nature (see p. 86, detail).

The representation of a kneeling figure in armor, such as the nobleman at the base of fig. 41, had a long-standing tradition in sculpture and manuscript painting as well as in stained glass. Jean Bourdichon's 1498–99 illuminations for the Hours of Louis XII (fig. 42) include an image of the king kneeling at prayer; he is surrounded by religious figures of particular relevance to France, from left the Archangel Michael, Charlemagne, Louis IX, and Denis. King Louis XII is dressed—as is the donor in the window—in armor and a surcoat. They both kneel on a tasseled cushion with their helmets before them. That of the king, appropriately, bears the royal crown. The men are profiled in three-quarter view; their piety is expressed by their contemplative gaze and their hands joined in prayer. For individuals of rank, such representation was obligatory. The person of privilege demonstrated his piety and thus his right to rule.

◁ **Fig. 41**
Saint Christopher and a Donor, French (Lorraine/Burgundy), ca. 1500–1510. Pot-metal, flashed, and colorless glass, vitreous paint, and silver stain, 225 × 64 cm (88⁹⁄₁₆ × 25³⁄₁₆ in.). JPGM, 2003.53.2

Fig. 42 ▷
Jean Bourdichon (French, 1457–1521), *Louis XII Kneeling in Prayer Accompanied by Saint Michael, Saint Charlemagne, Saint Louis, and Saint Denis*, from the Hours of Louis XII, Tours, 1498–99. Tempera and gold on parchment, 24.3 × 15.7 cm (9⁹⁄₁₆ × 6³⁄₁₆ in.). JPGM, 2004.1

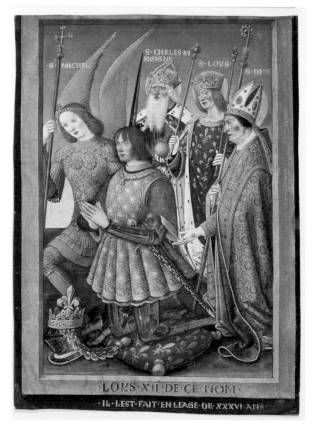

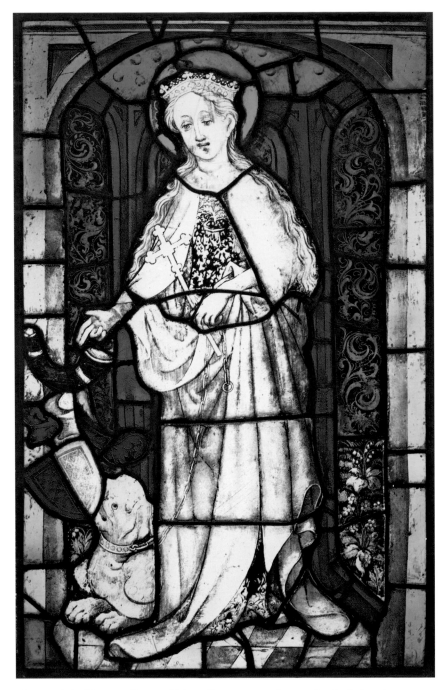

Fig. 43 · *Saint Margaret*, German (Cologne?), ca. 1420–30. Pot-metal and colorless glass, vitreous paint, and silver stain, 71 × 43.5 cm (27 15/16 × 17 1/8 in.). JPGM, 2003.36

These monumental works also served a broad public who would then have access to compelling images of the saints or other revered protectors. In wall paintings and altarpieces as well as stained glass, the subject matter included saints whom the faithful could call upon to intercede for them before God. Saints were often associated with the power to cure specific ailments or affect certain kinds of rescue. For example, Saint Nicholas, whose tomb is in the Italian port of Bari, protected sailors at sea. Saint Christopher, who carried the Christ child across a river, was invoked by travelers. Christopher's image was ubiquitous and, in addition to windows, this saint was often depicted in large-scale wall paintings at the entrances of churches to emphasize his oversight of those coming and going from place to place.

Saint Margaret was universally revered as the protector of women in childbirth, a role inspired by the story found in the *Golden Legend*, a widely circulated late-thirteenth-century compilation of saints' lives. Along with Barbara and Catherine, Saint Margaret was one of the "three holy maidens" most revered in the Middle Ages and Renaissance. Thrown into prison for her faith, she was confronted by the devil in the form of a dragon, which swallowed her. When she made the sign of the cross from within the beast, the dragon split open, and Margaret emerged unscathed. In a fifteenth-century panel, possibly from the Cologne region (fig. 43), the beast appears as a docile pet led by a leash. Richly dressed, Margaret is silhouetted against the mauve pilasters of the architecture and a dense blue damask-patterned background that evokes the sky. Her location in paradise is further established by the flower-strewn field at the lower right achieved by silver stain on blue glass to create green leaves. She gestures to the red-and-white shield of an unidentified donor.

Just as pregnant women invoked Margaret, those threatened by the plague begged Saint Sebastian to intercede on their behalf. The pandemic first engulfed Europe in the mid-fourteenth century, killing an estimated 40 percent of the population; it returned periodically, often in outbreaks of terrifying intensity, up through the early modern period (ca. 1800). A roundel of Saint Sebastian (fig. 44) shows the martyr being pierced by arrows, a common metaphor for being struck with illness. Sanguine is used to represent the blood from the saint's wounds in his chest and thigh. The thin mat of the background is modulated by extensive needlework to remove paint as well as by added line. Shading on the back of the glass follows the pattern of shadow on the right side of the saint's body. This sophisticated German work of about 1520–30, clearly influenced by Italian models, is unusual in

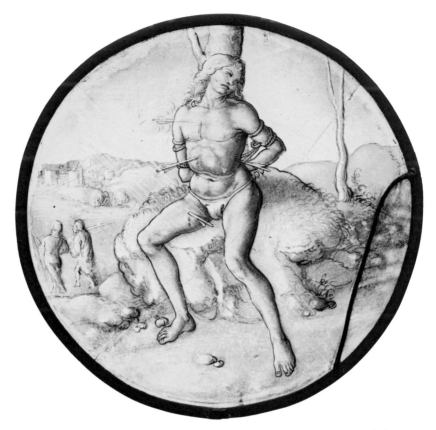

Fig. 44 · *Saint Sebastian*, German, ca. 1520–30. Colorless glass, vitreous paint, and silver stain, diam.: 19.5 cm (7 ¹¹⁄₁₆ in.). JPGM, 2003.67

that it isolates the figure of the saint and poses him in a sitting position, almost like a studio model. The fascination with the human figure, at once a demonstration of scientific observation and homage to a classical past, was a hallmark of fifteenth-century Italian art.

A New Kind of Patronage

In the Renaissance, particularly in Germany and Switzerland—where prosperous farmers and merchants redefined political power in their respective rural areas and cities—public figures sought representation in stained glass. Patrons developed a custom of donations and exchanges of personalized imagery. A panel showing the arms of the Eberler family (fig. 45) may have been created for a private home or for a civic structure, such as a town hall. In this small-scale work, which dates to about

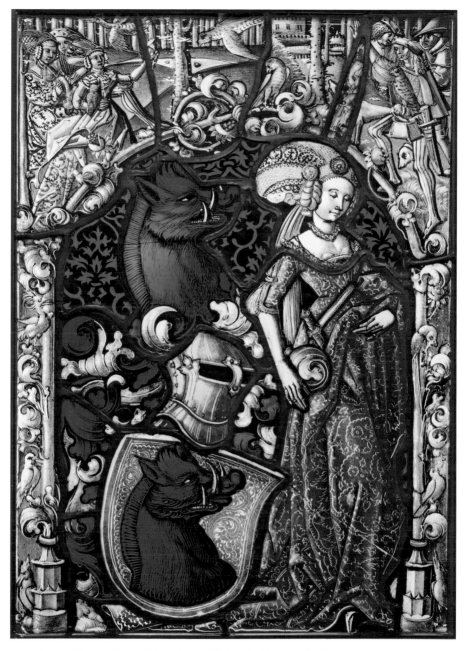

Fig. 45 · *Heraldic Panel with the Arms of the Eberler Family*, Swiss (Basel?), ca. 1490. Pot-metal, flashed, and colorless glass, vitreous paint, and silver stain, 44 × 31 cm (17 $\frac{5}{16}$ × 12 $\frac{3}{16}$ in.). JPGM, 2003.47

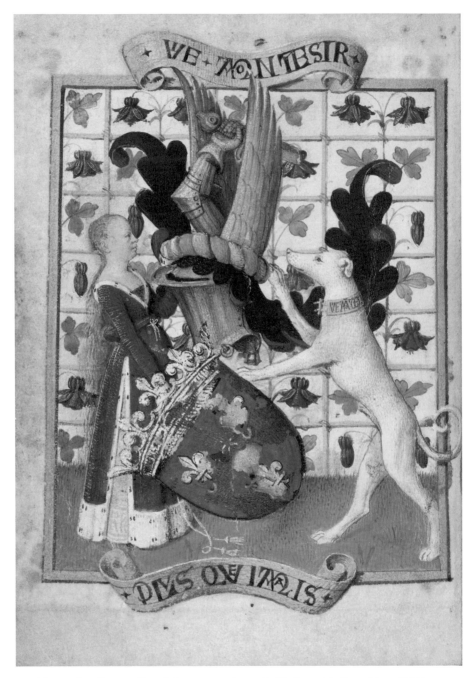

Fig. 46 · Jean Fouquet (French, born ca. 1415/1420–died before 1481), *Coat of Arms Held by a Woman and a Greyhound* from the Hours of Simon de Varie, Tours, 1455. Tempera colors, gold paint, gold leaf, and ink on parchment, 11.4 × 8.3 cm (4½ × 3¼ in.). JPGM, Ms. 7 fol. 2v, 85.ML.27.2v

1490, an elegantly dressed woman with an elaborate headdress supports the coat of arms. The prosperous Eberler family of Basel was evidently keen on depicting an atmosphere emphasizing courtly love and the leisure pursuits of the upper class. Densely painted, the panel's high-quality execution seems commensurate with its sophisticated subject matter. Flashed and abraded red glass in several shades is used in the boar's head crest and mantling of the shield. The artist laid down several intensities of mat, subsequently adding different trace lines before modeling the image with a highly varied removal of paint with stick and needle (on the reverse, the painter employed remarkably bold, uneven strokes). Hunting scenes appear in the architectural frame, which incorporates naturalistic intertwined branches populated by well-dressed men and women. The pursuit of falconry occupies the upper portion, set in a forest clearing with a castle in the distance. To the left, a page aids two women; one of them holds a falcon on her right arm as she looks up at a hawk pursuing a woodpecker. Depicted with lively veracity, the women are richly dressed and wear headdresses similar to that of the supporter of the family arms. A young man appears on the right with two male companions and two greyhounds. In reality, the hunt is that of love between the ladies on the left and the long-tressed young gentlemen on the right.

A comparison with the heraldic frontispiece painted by Jean Fouquet in the Hours of Simon de Varie (fig. 46) shows the strong relationship of manuscript and glass conventions of this genre. Fouquet's miniature, enlarged here, contains all the requisite devices: a rampant greyhound and a woman in an ermine-trimmed gown support a vividly colored shield; the great helmet and its crest rise majestically against the trellis of flowers, a parallel to the red background in the glass panel.

Prosperous Renaissance households in Switzerland displayed civic marriage panels in order to demonstrate family alliances. For more than two centuries, these panels were ubiquitous in homes, civic buildings, and taverns. Husband and wife invariably occupy the central scene, sometimes with their children. The Swiss panels consistently display coats of arms below the couple, the husband on the left and the wife on the right. Sometimes, the shields are between the couple, or at their feet. A stained glass design of 1553, commissioned by Sulpitius Haller and Barbara Flühmann, exemplifies this visual language (fig. 47). In place of the crested helmets of the nobility are beehives, symbols of domestic industry. The male supporter, dressed in the heraldic language of the shield, brandishes a winnowing fan, and the female holds a distaff—emblems long associated with gender-specific labor.

Fig. 47 · Hieronymous Lang (Swiss, active 1541–82), *Stained Glass Design for a Married Couple*, 1553. Pen and black ink with gray, ocher, brown, and orange washes, 24 × 21.7 cm (9 7/16 × 8 9/16 in.). JPGM, 89.GG.18

In northern Europe, individual men as well as civic associations (invariably composed of males) continued to commission panels throughout the sixteenth century. Often the subject of these panels represented their arms alone, not that of their spouses. For instance, Fridolin Kleger, bailiff of the Swiss Gaster region from 1548 to 1562, commissioned *The Suicide of Lucretia* (fig. 48; see also fig. 12, detail), dated 1561. The panel shows a variety of silver stain applications; the architecture and fruit on the green glass of the arch, a green mount on the blue glass of the shield, and the varied golds and yellows of the hair and robe of Lucretia. The back-painting is unusually loose and painterly, similar to that in the arms of Eberler, also from Switzerland (see fig. 45).

Fig. 48 · Workshop of Carl von Egeri (Swiss, 1510–62), *The Suicide of Lucretia*, 1561. Pot-metal
and colorless glass, vitreous paint, and silver stain, 33 × 23 cm (13 × 9 ¹⁄₁₆ in.). JPGM, 2004.64

In *The Suicide of Lucretia*, the upper section of the panel shows the Creation of Eve on the left and the Fall of Man on the right; in each representation, unlike medieval precedent, the couple is completely nude, an indication of Renaissance interest in the human figure as a subject of art. Capturing the viewer's attention, Lucretia, modeled in three-dimensional volume, displays an undraped leg and breast as she drives a dagger into her heart. According to a legend of the founding of the Roman Republic, Lucretia is a virtuous wife who prefers death to dishonor after being raped by Tarquin, son of the last Roman monarch. Her relatives and friends vow vengeance and swear they will never again submit to the rule of a tyrant. It is intriguing to speculate why this donor might have chosen this particular subject. Since Kleger commissioned the panel during his tenure as a government official, the panel presumably was a gift to a public or even religious institution. Did this minor bureaucrat see himself as proclaiming the ancient heritage of the Swiss Confederation, where the cantons had rejected the rule of a hereditary king? At the same time, would Kleger have felt that this mingling of classical and Christian themes reflected humanist values and proclaimed his cultivated tastes?

The nobility were keenly aware of progressive trends in art, seeing their prestige linked to sophisticated patronage. *Study for a Stained Glass Window with the Coat of Arms of the Barons von Paar*, by Georg Pencz, exemplifies this attitude (fig. 49). That the German patrons of this design favored Italianate influences is evident in the erudite Latin inscription, the classically inspired calligraphy, and the inclusion of a female nude reclining in a pose evocative of Roman river gods. The panel presumably would have been executed as a silver stain roundel with a separate border, the latter probably of colored glass. The border's inscription identifies the arms as those of Marcus Belidorus de Casnio, an Italian ancestor of the noble von Paar family, who acquired large estates in Styria and Bohemia. Hanging from the tree is a motto in Latin: *Stemmata virtuti et munificentie adaucta heroum propria* (Family trees devoted to virtue and munificence are characteristic of heroes).

Classical tradition in portraiture is also a hallmark of the Renaissance. Prototypes were available in collectable objects such as coins, cameos, and medals as well as sculpted images on ancient buildings. Politics of the time encouraged the revivals of these classical precedents in literature, ritual, and image. A roundel with the image of an emperor or a king (fig. 50), from about 1550, is arguably a generic image. The arresting profile, with its prominent nose, strong chin, and muscular jowl, suggests a symbolic portrait of both age and wisdom. The flat, smooth glass

Fig. 49 ▷
Georg Pencz (German,
1484/1485–1545), *Study for a
Stained Glass Window with
the Coat of Arms of the Barons
von Paar*, ca. 1540. Pen and
brown ink with gray wash,
diam: 24.8 cm (9 ¾ in.). JPGM,
83.GA.193

◁ Fig. 50
An Emperor or a King,
Netherlandish, ca. 1550.
Colorless glass, vitreous paint,
and silver stain, diam.: 25.5 cm
(10 ¹⁄₁₆ in.). JPGM, 2003.72

shows an excellent retention of paint. A light neutral wash forms the base of the face and shoulders. The artist partially brushed off the paint to reveal almost clear glass in the highlighted area on the shoulder on the left. Sanguine is used to create a warmer flesh tone that is distinguished from the armor. Effective alternation of thin trace line and stickwork creates the impression of light, tightly curled hair. The middle-aged but vigorous man clad in armor and wearing a crown suggests martial abilities combined with the wisdom to apply them judiciously.

Love as well as war inspired classical references, still within a rich Italianate tradition. An image of the bound Cupid in *A Fragment from The Triumph of Chastity over Love* (fig. 51) was produced in the southern Netherlands, possibly Antwerp about 1525–30. The moderately granular mat is applied smoothly and is varied to achieve three-dimensional effects. Additional marks in trace with sparing use of stickwork and needlework are carefully varied in size and intensity to contribute to volumetric modeling. The general effect is more of a wash drawing than of the graphic mark-making of many panels of this time. The lower section of the panel, however, is a restoration.

The scene illustrates Chastity, one of the six themes of the poem *Trionfi* (Triumphs) by the fourteenth-century Italian humanist Petrarch—the remaining five being Love, Death, Fame, Time, and Eternity. The poem describes a series of scenes presenting symbolic triumphal processions inspired by Roman antiquity. During the Renaissance, representations of Petrarch's *Trionfi* were popular in manuscript illuminations, *cassone* painting (decorated marriage chests), engravings, and birth and marriage salvers (trays). In the Love section of the poem, preceding Chastity, a triumphant Cupid is described vividly:

> **Four snowy steeds a fiery chariot drew;**
> **There sat the cruel boy; a threatening yew**
> **His right hand bore, his quiver arrows held,**
> **Against whose force no helm or shield prevail'd.**
> **Two party-colour'd wings his shoulders ware;**
> **All naked else; and round about his chair**
> **Were thousand mortals: some in battle ta'en,**
> **Many were hurt with darts, and many slain.** [6]

In this fragment illustrating Chastity, though, Cupid is a bound captive. He is restrained through the power of the virtuous women of the classical past, such as Dido, Lucretia, Penelope, and the Sabine women, shown gathered in a throng in back of the chariot.

Fig. 51 · *A Fragment from The Triumph of Chastity over Love*, South Netherlandish (Antwerp?), ca. 1525–30. Colorless glass, vitreous paint, and silver stain, 35.5 × 12.5 cm (14 × 4 15⁄16 in.). JPGM, 2003.70

Fig. 52 · Hans Sebald Beham (German, 1500–1550), *The Circumcision*, ca. 1522. Pen and brown ink, red chalk, and gray, red, and brown wash, diam.: 22.9 cm (9 in.). JPGM, 89.GG.7

Artists across Media

In workshops throughout the Middle Ages, designers took an active part in painting and supervising the fabrication of stained glass windows. However, these artists were largely anonymous in the early Middle Ages, before paper had been introduced and when most documentation was written in Latin on expensive parchment. Art historians have therefore attributed authorship based on the varied draftsmanship and composition of glass ensembles, assigning artists names such as Master of the Sainte-Chapelle. With the rise of a mercantile economy around 1500 that saw the development of printing, paper use, and writing in the vernacular, designs for painting on glass were frequently produced by artists who also achieved prominence in other media.

Because these artists can be identified by means of their business and tax records and contemporary biographies, there is proof that luminaries such as

Albrecht Altdorfer, Hans Sebald Beham, Albrecht Dürer, Hans Baldung Grien, and Hans Holbein the Younger designed stained glass windows. The Hirsvogel family executed glass in Nuremberg for a number of the city's artists, including Dürer and Beham. Some preparatory sketches made by Beham, who worked as an engraver, etcher, and painter as well as a designer of stained glass, woodcuts, seals, and medals, still exist. About 1522, he produced a series of circular drawings for subjects from the life of Christ, one of which is a carefully rendered image of Jesus's circumcision (fig. 52). The drawing may have been used as a cartoon, or possibly was meant to be copied again in a stained glass workshop, as it bears color notations and red chalk lines indicating the dimensions of glass sections and leading. The execution of a leaded window (fig. 53) based on a drawing from the series by Beham, *Ecce Homo*, shows the end result of the process. The panel incorporates light blue, green, and red flashed glass treated with vitreous paint and silver stain, surrounded by a border with an inscription in Latin: *Pōtius egreditur secumque ducit Jesum. Ecce ait*

Fig. 53 · Attributed to Hirsvogel workshop, *Ecce Homo* from a series of the Life of Christ, German, ca. 1525, after Hans Sebald Beham (German, 1500–1550). Colorless and pot-metal glass with vitreous paint, diam.: 30.5 cm (12 in.). New York, Metropolitan Museum of Art, 11.93.10

ad turbas [hom]inem sine crimine iustum (Pontius came forth and brought Jesus with him. Behold, he said to the crowd, a just man without fault).

Hans Holbein the Younger personified the complex, international climate of artistic production in the first half of the sixteenth century. Although probably the most distinguished portrait painter of his time, he also produced many designs for stained glass and for printed work, especially woodcuts. He was the son of a respected painter from Augsburg, Hans Holbein the Elder, who ran a workshop that produced large-scale altarpieces and wall paintings and also collaborated with stained glass painters, goldsmiths, and sculptors. In 1515 the younger Holbein and

his brother, Ambrosius, moved to Basel, where Hans was awarded a commission to paint portraits of Basel's mayor, Jakob Meyer, and his wife, Dorothea Kannengiesser (now in the Basel Öffentliche Kunstsammlung). In 1519 Holbein the Younger was accepted as a master in the painters' guild.

Holbein may have executed drawings for the panel *A Premonstratensian Canon* (fig. 54), dated about 1520, showing a member of an order of preachers; the Premonstratensians (sometimes also called Norbertines) were members of an order founded in Prémontré near Laon (France) in 1120 by Saint Norbert. The panel very probably came from the abbey of Rot an der Rot, which had been founded in 1126, about five kilometers from Berkheim, Germany, near the Swiss border. Unlike monks, who lived in seclusion, canons were engaged in pastoral ministry, and the Premonstratensians of the abbey ministered to the parish church in Berkheim. In 1497 the Holy Roman Emperor Maximilian I granted Rot an der Rot the status of Imperial Abbey, and its abbot thus became associated with the Council of the Princes in the Imperial Diet (assembly) of the empire. The abbey's medieval buildings were almost completely destroyed by fire in 1481 but were soon rebuilt, and in 1509 the new church was dedicated. Perhaps this window was donated to the abbey church to help embellish it after the recent rebuilding.

◁ **Fig. 54**
A Premonstratensian Canon,
Swiss, ca. 1520, possibly after
Hans Holbein the Younger
(German, 1497/1498–1543).
Pot-metal and colorless glass,
vitreous paint, and silver stain,
61 × 52 cm (24 × 20½ in.).
JPGM, 2003.66

Fig. 55 ▷
Hans Holbein the Younger
(German, 1497/1498–1543),
Portrait of a Scholar or Cleric,
ca. 1532–35. Black and red
chalk, and pen and brush and
black ink, 21.9 × 18.5 cm
(8⅝ × 7¼ in.). JPGM, 84.GG.93

Many of Holbein's designs for glass date from his years in Basel. Some executed panels have survived, notably a window of the sainted Emperor Henry II with the arms of Basel from the cloister of the Cistercian abbey of Wettingen, made about 1519–20. The heavy column with its leafy swags in the Premonstratensian panel (see fig. 54) is similar to the architectural details Holbein used for a series of twelve drawings for stained glass dating from about 1525–28, depicting the Passion of Christ (now in the Kunstmuseum Basel). The canon is richly dressed in a fur cloak and reads from a heavy volume, recalling many of Holbein's portraits, including those produced later, such as the *Portrait of a Scholar or Cleric*, from about 1532–35, (fig. 55). It was common for stained glass workshops to use materials from several different designers. In the case of the Premonstratensian panel, for example, some of the elements suggest the work of Urs Graf, the engraver, painter, and woodcut and stained glass designer who was active in Basel at the same time as Holbein. The lively depiction of a male water spirit (in the lower right corner) armed with a tortoiseshell shield and carrying a woman on his back evokes the vitality and expressiveness of Graf's many drawings.

The Invention of Printmaking

The invention of the printing press represented a watershed in the history of art and society. The influence of printmaking on stained glass affected both the arrangement of the glass workshops and the expectations of those patrons who were partial to a particular set of prints and wanted to see these same images in their commissions. Prints, however, were monochromatic, viewing was personal, and paper was ephemeral. By transferring images from prints to glass, permanent images were produced that embellished architecture and served as public forms of art.

The Getty collection includes several objects that illustrate the relationship of printmaking and windows in the Netherlands during the first half of the sixteenth century. By that time, dissemination of prints had become standard, especially for the production of roundels. The very genesis of the prints, frequently in series, paralleled earlier practices in stained glass. The printmaker commissioned a series of drawings by an artist, who anticipated their rendition as woodcuts or engravings.

Silver stain narrative roundels, like the prints of the time, were most frequently produced in series and were replicated, again like prints, depending on demand. *The Arrest of Christ* (fig. 56), from the northern Netherlands, undoubtedly was part of a series of the Passion. The image is derived from the second woodcut in the large round Passion series by Jacob Cornelisz van Oostsanen (fig. 57). This artist

Fig. 56 △
The Arrest of Christ, North
Netherlandish, ca. 1530.
Colorless glass, vitreous
paint, and silver stain, diam.:
27.4 cm (10 ¹³⁄₁₆ in.). JPGM,
2003.59

Fig. 57 ▷
Jacob Cornelisz van Oostsanen
(Dutch, 1465/1470–1533),
Arrest of Christ, from the series
The Round Passion of Christ,
1517–33. Print, diam.: 24 cm
(9 ⁷⁄₁₆ in.). Amsterdam,
Rijksmuseum, RP-P-BI-6261

was a member of a family of painters and printmakers located in the Netherlands, primarily Amsterdam. Scholars have identified about two hundred woodcuts and twenty-seven paintings in the artist's oeuvre. His vivid designs translated well into glass. Instead of a discursive narrative, each image in the woodcut series focuses on a specific moment in time. Extraneous detail is minimal, and almost all the figures are on the same plane. Silver stain adds rich yellow hues, not available in prints, to the finished roundel. Various levels of intensity in the washes and the removal of paint create a sense of volume. Illusion of depth is further enhanced by back-painting on the reverse of the glass in areas meant to be in shadow.

It is not possible to determine the extent of a series from the presence of a single roundel. Even if the full series of prints is known, a stained glass commission may have reduced the number of scenes because of the specific architectural context—for example, fewer window openings than scenes. The patron would select the scenes from the print series most relevant to the narrative. As a corollary, the installation may have included additional scenes beyond the series.

In a world where literacy was rare and, until the Reformation, dominated by clerical Latin, alternate means of reaching the faithful were essential. One effective approach was the creation of lists, seven being a common series number. A meditative series such as the Seven Joys and Seven Sorrows of the Virgin Mary helped listeners and viewers focus empathetically on events in the life of Christ. For example, the east window of the church of St. Peter and St. Paul in East Harling, Norfolk, created between 1463 and 1480, bears an arrangement of scenes that accords with the Seven Joys and Seven Sorrows.

The pastoral efforts of the Church grouped seven specific charitable acts as the Corporal Works of Mercy. In 1281 the Lambeth Constitutions for the Archdiocese of Canterbury made the Seven Corporal Works of Mercy mandatory teaching and, in the following century, *The Lay Folks' Catechism* from York translated them into Old English, which can be paraphrased thus: Of which the first is to feed those that are hungry; the second, to give drink to those who are thirsty; the third, to clothe those who are without clothes; the fourth is to shelter those who are homeless; the fifth is to visit those who lay in sickness; the sixth is to help those in prison; the seventh is to bury the dead who are churched.

The Corporal Works of Mercy appear in numerous exemplars by Renaissance artists, invariably disseminated in printed form. A pen-and-ink drawing, *Freeing the Prisoners* (fig. 58), by Pieter Cornelisz Kunst, a Netherlandish artist, is dated 1532 and was destined for such a stained glass series. It illustrates the Sixth Work

Fig. 58
Pieter Cornelisz Kunst
(Dutch, ca. 1484–1560/1561),
Freeing the Prisoners from
the series The Seven Acts
of Mercy, 1532. Pen and
black ink over black chalk,
23 × 16.8 cm (9 1/16 × 6 5/8 in.).
JPGM, 92.GA.77

of Mercy, to visit—and in this case to ransom—prisoners. The theme was so well received that the artist created three different versions of the Works of Mercy series.

Maerten van Heemskerck's works often served as models for stained glass. A resident of Haarlem, he was one of the major artistic figures in the northern Netherlands. He traveled widely, however, and while in Italy, between 1532 and 1535, produced many drawings of the antiquities of Rome that were notable for their drama and antiquarian interest. His series for the Last Judgment and Six Works of Mercy was reproduced in print by Dirck Volkertsz Coornhert in 1552. The panel *Housing the Stranger* (fig. 59), dated about 1560–70, is a close adaptation of van Heemskerck's design. The petitioner appears as a pilgrim, with a broad-brimmed hat, staff, and leather pouch. The image affirmed the value of pilgrimage at a moment when the time-honored practice was under attack from Protestant reformers. A stopgap at the lower right contains elements of another work in the series, *Giving Drink to the Thirsty* (fig. 60).

The panel is composed of uncolored glass with two shades of vitreous paint. Back-painting forms a solid wash across the entire exterior surface, creating a uniform opaque effect no matter the angle of light. The background imparts a rich texture to the work, from the smooth uniformity of the wall to the dark, shadowed portal on the left and interior spaces on the right. Close inspection reveals extremely fine stickwork, here undoubtedly done with a needle, on the shoulder of the pilgrim being welcomed. The artist uses parallel lines to accent the

◁ **Fig. 59**
Housing the Stranger from the series The Seven Acts of Mercy, Dutch, ca. 1560–70, after Maerten van Heemskerck (Dutch, 1498–1574). Colorless glass, vitreous paint, and silver stain, 31 × 26 cm (12 3/16 × 10 1/4 in.). JPGM, 2003.74

Fig. 60 ▷
Dirck Volkertsz Coornhert (Dutch, 1522–1590), *Giving Drink to the Thirsty* from the series The Last Judgment and Six Works of Mercy, 1552, after Maerten van Heemskerck (Dutch, 1498–1574). Etching and engraving, 24 × 18.9 cm (9 7/16 × 7 7/16 in.). London, The British Museum, 1875, 0710.2820

perspectival recession of the wall, enabling the viewer to empathize with the realistic space and the drama of the scene.

In the Middle Ages and the Renaissance, works of art were almost never brought into being without the express demand of a patron. Such commissions were invariably destined for a specific placement and audience. The decisions by the artists concerning color, composition, and painting style demonstrate the desires and expectations of the cultures in which they lived.

Notes

1 *Piers the Plowman's Crede*, lines 119–22, in James Dean, ed., *Six Ecclesiastical Satires* (Kalamazoo, Michigan, 1991). Transliteration by George W. Tuma and Dinah Hazell, *Medieval Forum*: English Department, San Francisco State University (www.sfsu.edu/~medieval/complaintlit/plowman_creed.html, accessed February 8, 2013): "We have built a large broad convent, a church, and a chapel; its tall chambers have windows and very high walls that must be decorated, painted and brightly polished, with gay glittering glass glowing as the sun."

2 Richard Marks, *Stained Glass in England during the Middle Ages* (Toronto, 1993), 14, 188–89, pls. IIc, IIId.

3 Charles Winston, *An Inquiry into the Difference of Style Observable in Ancient Glass Paintings, Especially in England: With Hints on Glass Painting, by an Amateur* (Oxford, 1847), 347–48.

4 Ibid., 349.

5 Roger S. Wieck, *Time Sanctified: The Book of Hours in Medieval Art and Life* (Baltimore, 2001), 164.

6 Thomas Campbell, *The Sonnets, Triumphs, and Other Poems of Petrarch* (London, 1879), 322.

Collecting Stained Glass

Elements of architectural decoration, such as stained glass windows, become objects in museums or private collections after they have lost their original context—for example, with the destruction of a building—or after having been deliberately removed from an extant site. Over the centuries, and long before they became museum pieces or collector's items on the art market, these works were sometimes removed from their original locations and placed in new ones. This re-placing happened in churches, for example, where windows were repositioned due to successive renovations.

Among the best-known examples of this practice are the so-called *belles verrières* of Rouen Cathedral, which had been created about 1200 to embellish the nave. The term *belles verrières* (beautiful windows) refers specifically to the Rouen windows and apparently was introduced in early modern times to refer to the panels' intense colors. The blue and red palette was a novelty at a time when window glass was predominantly grisaille. In the 1270s, when the nave walls of the cathedral were pierced to provide subsidiary chapels, the windows were removed from their original openings, and the medallions were truncated to be inserted into the new, narrower lancets. Some of these panels were dispersed in the nineteenth century; they are now found in various collections, including those of the Worcester Art Museum (Worcester, Massachusetts), the Glencairn Museum (Bryn Athyn, Pennsylvania), and the Metropolitan Museum of Art (New York). Thirteenth-century windows in Reims Cathedral were also repositioned from the west facade to the transept to accommodate liturgical changes. These kinds of changes were due to a variety of factors: the reconstruction of elements of churches in a more up-to-date style, the need to expand to make space for a growing population, and repairs made after natural or man-made disasters.

When surveying the works of art in our modern museums and private collections, we reflect on the reasons for their acquisition. Sometimes society simply changed behavior, as in the case of the transition from pagan to Christian worship in the Middle Ages that made antique statues irrelevant as objects of worship. Often, however, changes were brought about by divisive conflicts such as military invasions and internal revolutions. In England, where the impact of the Reformation was particularly harsh, stained glass that survived mostly did so in fragmentary form. With the dissolution of the monasteries between 1536

and 1539 under Henry VIII, many of the buildings were converted into residences for the newly created nobility. As a result of this secularization, the stained glass in cloisters and monastic churches lost its original religious function. Over time, the windows fell into disrepair or were recycled to extract the valuable lead they contained.

With the ascent to the throne in 1547 of Henry's son, Edward VI, official policies began reflecting the zeal of kiconoclastic reformers. Royal injunctions mandated the destruction of religious imagery in sculpture, stained glass, books, and on walls. Statutes demanded that citizens "destroy all shrines . . . pictures, paintings and all other monuments of feigned miracles . . . so that there remain no memory of the same in walls, glass-windows, or elsewhere within their churches or houses."[1] Official documents of the time as well as historical reference materials provide abundant evidence that the attacks on art that followed such orders were seen as honorable actions. Some places even have explicit records written by the perpetrators themselves. Of course, with destruction came the need to replace the offending windows with glass that was devoid of religious imagery—a project demanding considerable expense. Norwich, the center of the wool trade of East Anglia, was a wealthy city, able to afford new windows to replace those that had been removed. The 1547–52 inventories for St. Mary Coslany in Norwich, for example, include a note about "the glasying of fyften wyndows with new glasse."[2] Some windows survived the initial destruction only to incur additional despoliation in the 1640s during the Commonwealth, when Puritans took over the government. Norwich city records of the mid-seventeenth century note new windows for the churches of St. Benedict, St. Gregory, St. Peter Mancroft, and St. Stephen. Other, less wealthy localities attempted to comply with these injunctions by whitewashing windows to mask the subject matter. Both textual references

Fragments of glass reset in a
window tracery, fifteenth
century, St. Peter's church,
Canterbury, England

Fig. 62 ▷
*Head of an Angel from
the Last Judgment*, English
(Gloucestershire), ca. 1510–17.
Colorless glass, vitreous paint,
and silver stain, 17 × 15.5 cm
(6 $^{11}/_{16}$ × 6 $^{1}/_{8}$ in.). JPGM, 2003.62

and physical remains confirm this practice. For example, faded whitewash on a fif-
teenth-century panel, now in the Walker Art Gallery, Liverpool, obscures the sym-
bol of the Trinity in the form of a shield (*scutum fidei*). Fortunately, not all medieval
and Renaissance stained glass windows in England were destroyed during the Ref-
ormation. Important ensembles remain in structures such as York Cathedral, Can-
terbury Cathedral, and the parish church of St. Mary in Fairford, discussed below.
More modest parish churches—for example, St. Peter's in Canterbury—frequently
retained medieval decorative fragments that restorers grouped in the traceries (the
elaborate upper sections of the stained glass windows) (fig. 61).

Recent research documents resistance to Protestant directives in the northern
counties of Cheshire and Lancashire.[3] The influence of powerful families in York
protected its great cathedral and many of that city's parish churches. For instance,
the parish church of Fairford, Gloucestershire, rebuilt within living memory of the
reformers, retains its extraordinary narrative. Fairford's stained glass was most
likely spared because it was easily recognizable as depicting the life of Christ. Since

the windows did not emphasize honoring saints or doctrinal messages about eccle-
siastical authority, later viewers were apt to interpret them as instructional, not
devotional.[4] *Head of an Angel from the Last Judgment* (fig. 62) has been associated
with this series. The piece was probably detached during the restoration of the
immense Last Judgment window that occupies the west end of the church.

During the eighteenth century, a growing interest in the Gothic-revival style
fostered a renewed appreciation of stained glass. The author and arbiter of taste
Horace Walpole built what he described as a "little Gothic castle" in the London
suburb of Strawberry Hill between 1749 and 1776; it was replete with Gothic arches
and decorative details (fig. 63). The traceries of the house's Gothic-revival windows
are glazed with fragments of stained glass of the sixteenth and seventeenth centu-
ries as well as with numerous Netherlandish roundels.
Throughout the Romantic Gothic revival and well into
the nineteenth century, stained glass was collected as
a decorative element that added to the desired atmo-
sphere, with little or no regard to its historical or
iconographic context. Stained glass was considered an
essential backdrop for mid-nineteenth-century aristo-
cratic armories. Composite panels of disparate frag-
ments and heraldic glass, in particular, were favored in
the libraries and great halls of the wealthy, such as the
London residence of the architect Sir John Soane, which
he bequeathed as a museum (open to the public since
1837). Only toward the end of the nineteenth and the
beginning of the twentieth centuries was stained glass
considered an art in its own right and a subject worthy
of scholarly investigation.

Fig. 63
The library at Strawberry
Hill, Twickenham, England,
1749–76

Records of dealers in stained glass date to the mid-eighteenth century. Already in 1761, a London commercial gallery organized an exhibition of Netherlandish roundels. A June 1808 sales catalogue from the London auction house Christie's asserts that the collection being sold was assembled by "a Gentleman of enlarged information and fine taste . . . from the suppressed Churches and Religious Houses in Germany, France, and the Netherlands."[5] That sale included not only popular small roundels but also many large-scale panels, measuring from one to more than two meters tall (about three to seven feet).

Members of Switzerland's intellectual class exhibited an early appreciation of Swiss heraldic glass, such as *The Suicide of Lucretia* (see fig. 48). The poet and painter Johann Martin Usteri collected such glass and also wrote descriptions of

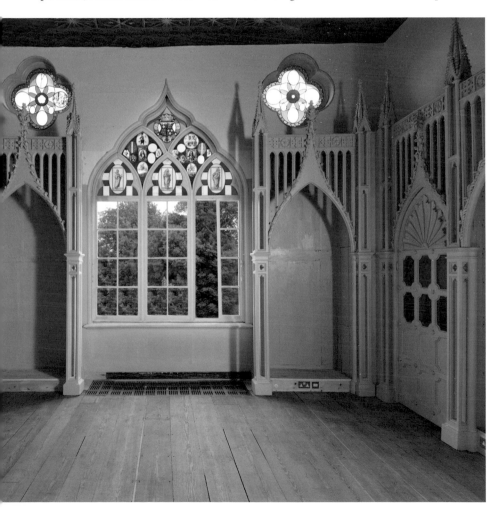

the glazing done in Swiss locations such as Königsfelden, Baden, Wettingen, and Stein am Rhein. Beginning in 1816, Johann Vincent, a merchant residing in Constance, purchased panels on his business trips through the Swiss countryside, and as early as 1833, his holdings were exhibited in the civic hall, the Capitalsaal, next to the cathedral in Constance. The Vincent collection was auctioned off in 1891, and a number of museums, including the Los Angeles County Museum of Art, eventually acquired items from it. Fortunately, other installations also survive. The collection of Swiss and German glass assembled by the eighteenth-century Swiss writer and patriot Johann Caspar Lavater, for example, remains intact. Prince Leopold Friedrich Franz of Anhalt-Dessau acquired it in 1782 and had his purchases installed in a "folly," a neo-Gothic house in a park in Wörlitz, Germany, where they can be seen today. (Wörlitz Park, a garden site surrounding the Gothic house and open to the public since its foundation, was added to the UNESCO World Heritage List in 2000.)

In the United States, the newspaper publisher William Randolph Hearst emerged as one of the world's foremost collectors of stained glass in the twentieth century. Hearst's collecting goal was to assemble architectural elements in order to install them in his various homes, located in California, New York, and Wales. Other collectors, with more modest aspirations, collected small-scale English and Swiss heraldic panels. The pioneer automobile manufacturer Henry Ford, for instance, installed such panels in his home in Grosse Pointe, Michigan.

A number of fragmentary pieces in the Getty collection possess considerable antiquarian and aesthetic appeal, qualities that have engaged collectors from the beginning. Many of these small fragments found their way into collections as a result of being left behind in restorers' studios after the completion of a restoration campaign. There are several answers to the question of how studios were allowed to retain historic pieces: works were deemed too fragmentary to be reinstalled, they were kept as models for the training of glass painters working in historical styles, or they may have been a means of surreptitiously repaying the restoration shop that had underbid on a job. We find similar types of fragments in the collection of the antiquarian Philip Nelson, who in 1913 published the first general survey of English windows, *Ancient Painted Glass in England, 1170–1500*. By being on good terms with the artisans who worked on the restoration of medieval monuments, Nelson amassed a large collection of stained glass, some of which the London auction house Sotheby's sold for his widow in 1953. The Walker Art Gallery in Liverpool purchased more than four hundred pieces dating from the

thirteenth through the mid-twentieth century. Within this collection are several groups of heads and sections of bodies, similar to the Getty Museum's collection of heads, including the aforementioned *Head of an Angel from the Last Judgment* (see fig. 62) and two angels that retain both head and torso, dating to about 1420–30; one of the angels is illustrated elsewhere in this book (see fig. 9).

Collectors and restorers have often grouped pieces of glass to make composite panels. The earliest work at the Getty is an assemblage of elements dated about 1210–25 (not shown here). The juxtaposition of fragments of heads, drapery, and architectural elements suggests a scene of figures gathered about a table. The elements are superbly painted, exemplifying the twelfth-century text by Theophilus that describes three primary applications of paint—first a light wash, followed by a medium to strengthen the shadow, and finally an opaque trace to establish contour.

The common practice of grouping stained glass panels from disparate sites parallels the way fragmentary remains of several windows were joined together to form a single panel in many churches, already mentioned for the group of fragments in St. Peter's in Canterbury (see fig. 61). Numerous museum collections include examples of such composite windows. The restorer Samuel Caldwell, working in Canterbury from 1862 to 1908, created an enormous panel for collectors that measures six and a half meters (about twenty-one feet) high. This panel combines French and English figural work, heraldic shields, and quarry glazing. The quarries—small, colorless panes of glass in diamond shapes—are composed of some original pieces and some copies that Caldwell made and then treated with acid or black paint to simulate the pitting on the original pieces. This work is now in the Walker Art Gallery, Liverpool. Although it is much smaller, a panel in the Getty Museum, *Composite Panel with Lute-Playing Angel* (not shown here), incorporates fragments from England dating to about 1450 and 1553 and from the sixteenth-century Netherlands.

Two French pieces illustrate the fairly common practice of setting heads, or other intact elements, within a surround of stopgaps. *Head of a Young Man* (fig. 64) is silhouetted against a circle of red-and-blue stopgap pot-metal glass. Thus the panel functions as a portrait medallion, drawing attention to the facial features and the painter's skill. The collector could easily display such a piece as a whole suspended in front of, or leaded into, a window. Collectors today will often use light boxes to provide added flexibility with display. In that case the glass is framed and lit from behind, thus eliminating the need to position the window to receive natural light.

A larger and more complex panel, the *Head of an Angel or Saint* (fig. 65), is composed of an original core and multiple additions. The head is a stunning example of

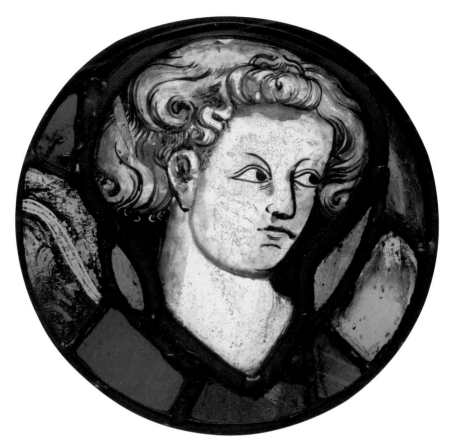

Fig. 64 · *Head of a Young Man*, French, ca. 1320–30. Pot-metal and colorless glass, vitreous paint, and silver stain, diam.: 21 cm (8 ¼ in.). JPGM, 2003.29

a style of early-fifteenth-century French painting that is possibly associated with the artistic circle of Bourges. Elegant lines trace the contours of the features, exuding a monumental, placid simplicity. As a foil, the blond hair tumbles about the face in multiple thin waves. The face, the hair, and a third of the red halo on the right of the image form the original core. The rest of the halo and the hand, body, and background are executed on new glass painted to approximate an antique patina. A segment of hair above the forehead, also a replacement, is visibly different in its more neutral tones. But the leaves are palimpsests, that is, medieval glass wiped clean of the original paint and repainted with the modern design—the restorer was marketing to a collector who appreciated the value of older glass.

In 2003 the Getty Museum acquired fifty-six stained glass panels and added another one the following year. These works, which date from about 1210 to about

Fig. 65 · *Head of an Angel or Saint*, French (Bourges?), ca. 1410. Pot-metal and colorless glass, vitreous paint, and silver stain, 47 × 47 cm (18½ × 18½ in.). JPGM, 2003.34

1575, come from seven Western European countries and include examples of techniques ranging from those found in a richly colored window of the thirteenth century to those used to create the small-scale, uncolored panels of drawings on glass that were popular in the sixteenth century. The museum's display created in 2010 grouped the works to evoke a sense of architectural scale and to demonstrate their relationship to other art forms.

Notes

1 Richard Marks, *Stained Glass in England during the Middle Ages* (Toronto, 1993), 230.

2 Ibid., 231.

3 The international organization Corpus Vitrearum has made inventories of extant glass and also explored records of destruction. See especially Penny Hebgin-Barnes, *The Medieval Stained Glass of Lancashire*, Corpus Vitrearum Medii Aevi: Great Britain, 8 (Oxford, 2008).

4 Sarah Brown, "Repackaging the Past: The Survival, Preservation, and Reinterpretation of the Medieval Windows of St. Mary's, Fairford, Gloucestershire," in *Art, Piety, and Destruction in the Christian West, 1500–1700*, ed. Virginia Raguin, 91–102 (Farnham, Surrey, England, and Burlington, VT, 2010).

5 Sales catalogue, Christie's London, June 1808, title page.

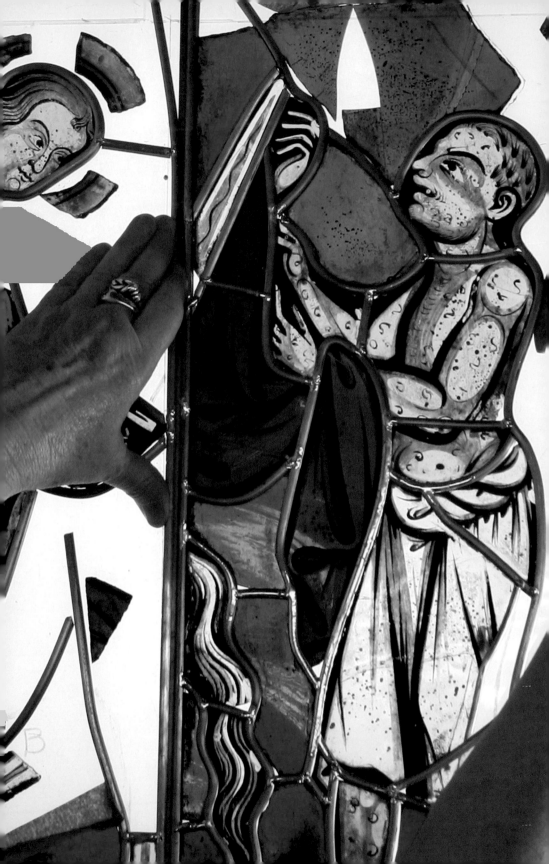

Challenges of Restoration and Display

Precious relics from the past—including, of course, stained glass—invariably do not come down to us unscathed. The very presence of these stained glass works in a museum setting is the result of their removal from their original contexts. Determining what to retain, display, alter, neglect, or destroy from the past is a sensitive process and one that, ideally, reflects a thoughtful consideration of the values of the society that produced the given object. A museum also faces the challenge of how best to preserve and exhibit the collection it acquires.

Throughout the history of collecting and display, the motivations for acquiring could be diverse, for example, the patriotic desire to preserve a disappearing heritage or, in the case of Horace Walpole (mentioned in the previous chapter), self-promotion as a gentleman. In some instances, collecting art was an act of resistance. As Catholics in England gradually acquired religious freedom during the latter eighteenth century, collecting became an intense, doctrinal statement. Around 1800, the Catholic recusant Sir William Jerningham built a Gothic-revival chapel for his family estate, Costessey Hall, near Norwich, and subsequently acquired eighty panels of glass from European sites that had been secularized during the Napoleonic era. Carefully arranged to achieve a formal thematic balance, the windows filled tall lancets on all sides of the chapel. In the center, above the altar—where the Sacrament took place—were images of the Eucharist. In 1913, after the death of Sir William's descendant (Sir Fitzherbert Stafford-Jerningham), Costessey Hall was dismantled and the panels were dispersed, entering many collections, including those of the Victoria and Albert Museum in London and the Metropolitan Museum of Art in New York. The fortuitous survival of these windows is a good example of how their transfer to museums inherently meant the suppression of their past, both in their original devotional function in monastic cloisters and churches and their later meaning to practitioners of a newly tolerated faith.

Today, scholars and museums strive to reinvest these objects with their original meanings through various approaches to gallery installation, wall text, and education that help make the past vivid for modern audiences. The earliest museums in

Fig. 66 · Restoration of *Saint Martin Dividing His Cloak with the Beggar*, possibly Tours, St. Gatian Cathedral, ca. 1245–48. Pot-metal and colorless glass, vitreous paint, 69.8 × 73.5 cm (27½ × 29 in.). Baltimore (MD), Baltimore Museum of Art, 1941.397

the United States actually attempted to do just that. For example, in 1903, when Isabella Stewart Gardner opened her museum in Boston (then called Fenway Court, but known today as the Isabella Stewart Gardner Museum), she purposely mingled vestments, manuscripts, sculpture, tapestries, paintings, metalwork, porcelain, wall coverings, and furniture—all without identifying or descriptive labels. Her objective was to create a context and convey a sense of juxtaposition and surprise for the visitor, believing that the experience of one object contributed to the interpretation of the next. In addition, her will mandated that the placement remain unchanged; her wishes have been respected to this day. As the twentieth century progressed, however, American museums increasingly began prioritizing definitions of period style and artistic identity over context. This development paralleled a modernist belief that the historical object now understood as a work of art possesses inherent qualities capable of moving a viewer in ways unlike those of utilitarian or everyday objects. Thus works of art were set in modern spaces, surrounded by white walls, and each object was contemplated as a separate entity. But nowadays, earlier concepts of context are returning. We find increasing interest in thematic display, sometimes achieved through temporary exhibitions that reunite original collections, and the exploration of influences, such as the interplay of Asian and European art in the eighteenth and nineteenth centuries.

In order to display stained glass, its physical structure must be intact. Since windows in collections had been removed from their original settings, they all needed some level of repair, ranging from a reinforced frame to extensive reconstruction. Restorers of the past, whether working alone or for collector/clients, invariably wanted to produce images that appeared complete even if they had acquired the panels in fragmentary form. Thus they often painted new pieces to make up for what was missing. Because a stained glass window is composed of numerous segments of glass held together by lead cames, an authentic segment is often juxtaposed with a modern replacement. The first step to studying and appreciating historical stained glass windows is to determine how extensively they have been restored. To do so, the restorer closely examines the stained glass panels from the front and back in both transmitted and raking light. The latter often reveals differences in texture and in paint color that mark a replacement from the original. Identifying the presence of modern techniques is a relatively easy way to determine the age of a panel. For example, a restorer today would make a clean cut with a diamond-tipped glass cutter rather than spending time cutting a grozed edge by nibbling away in the medieval manner. Furthermore, a modern artist would remove a layer of glass using

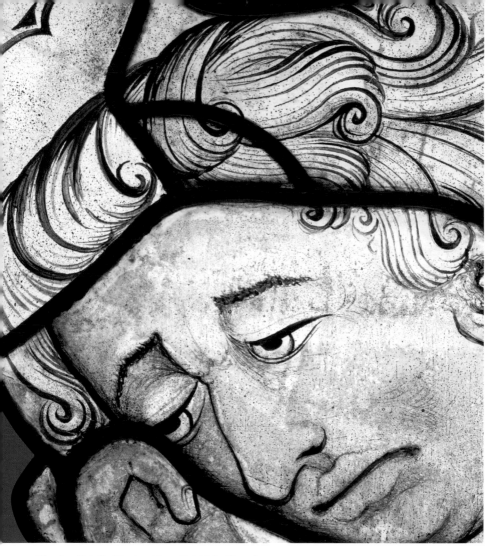

Fig. 67 · Detail of the head from *Saint John* (fig.29)

acid etching, avoiding the lengthy abrasion technique evident in the halos in *The Crucifixion* (see fig. 7) and *Saint Christopher and a Donor* (see fig. 41).

The upper left side of the head of Saint John (fig. 67, detail; see fig. 29 for full image) illustrates how a competent restorer created a new segment to augment a fragmentary base. John's facial area and halo are largely intact, but loss occurred to the extreme left, in the segment directly over the forehead. The restorer was diligent in mixing just the right shade of vitreous paint to match the original on the interior surface. In reflected light from the exterior, however, the segment has a different tone. The pitting on the glass, which resulted from weathering over a period of more than five hundred years, is replicated in paint. The original shows very fine,

Fig. 68
Detail of the shield from
Saint Christopher and a Donor
(fig. 41)

almost uniform pits, while the paint splatter used by the restorer is far more varied and feels quite different to the touch. The Getty Museum also possesses a panel showing the head and upper torso of the Virgin (not shown here), a companion piece to the panel of Saint John; the Virgin's halo, which is entirely modern, shows the same replacement painting style used by this restorer.

Sometimes a replacement reflects such a characteristically modern handling of the paint that the restoration is immediately obvious to the eye. For example, the upper-left quadrant of the coat of arms in *Saint Christopher and a Donor* (fig. 68, detail; see fig. 41 for full image) is a replacement. The painter has given a uniform, granular mat as a base, but one that lacks the appealing transparency that is so evident in the original. The rendering of the heads of the three wolves is uniform, showing a flat surface and an unvarying brushstroke, especially evident in the outline of the teeth and protruding tongues. Apparent even by sight, but even more evident to the touch, the glass is of a thin, machine-rolled type that did not exist in the early sixteenth century when this window was made.

These types of replacement are relatively innocuous, although to a discerning purist, any intervention that fools the eye into believing that the replacement is part of the original object is suspect. In contemporary restoration practices, researchers

advocate for some visible indication that a segment is replaced. These can be very subtle, such as tiny initials, or an addition of a limited crosshatch that is visible only upon very close inspection. Today, the belief that a modern painter can copy old glass and produce a seemingly authentic image is rejected. A highly interesting study piece, the torso of *The Resurrected Christ Blessing* (fig. 69)—probably from the area of Norfolk, England, and dating about 1450–70—illustrates the difficulties inherent in stained glass restoration. When it was discovered, in a commercial glass shop in The Hague in 2000, the fragment was set into a modern rectangular surround of red and orange segments. The head was provided with a peaked hat, making the figure look like a tiny Napoleon. Before the piece entered the Getty collection, a restorer had removed the frame and completed the head by adding a

Fig. 69
The Resurrected Christ Blessing, English (Norfolk?), ca. 1450–70. Colorless glass, vitreous paint, and silver stain, 18.6 × 15.3 cm (7 5/16 × 6 in.). JPGM, 2003.42

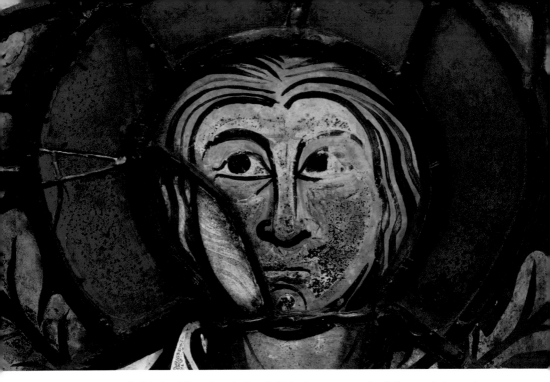

Fig. 70 · Detail of the head from *Seraph*, French (Reims), ca. 1275–99 (p. 4). Pot-metal glass and vitreous paint, 35 × 69 cm (13 ¾ × 27 ¾6 in.). JPGM, 2003.28

curved crown of hair framed by a halo. Only close observation reveals a difference between the silver stain in the original section of the halo close to the face and the new segment. Apparently, the restorer assumed that the repaired work would be accepted as genuine.

Such practices—even to the extreme extent of replacing damaged work with entirely new copies—were common in the past and were justified by patrons and artists committed to restoring churches to their original splendor; a damaged piece could be made "as good as new" by placing the original over a light board, then adding a new piece of glass over it, and tracing the features of the original on the new glass. Such approaches, however well or ill intentioned, resulted in excessive and tragic interventions. Current attitudes advocate the retention of the original, no matter how fragmentary. Modern techniques aid this goal, since unsightly mending leads that were used in the past can now be avoided for delicate work. Edge-bonding (gluing along the edges) with various modern products can now produce a virtually invisible mend, even in works with multiple fractures.

In the past, restorers apparently had access to a considerable amount of original material in fragmentary form. Thus they felt entitled to reuse old glass to restore windows. When the segment used to replace a missing piece is old glass, it is

referred to as a stopgap. In the panel *Housing the Stranger* (see fig. 59), a stopgap from another panel in the same series appears on the lower right; its color blends in, but its subject matter is different. When an older element has been repainted, it is called a palimpsest, which is the same term used for scraped and reused manuscript pages. Frequently the restorer resorted to cleaning off the original paint with acid. The late-thirteenth-century *Seraph* (fig. 70, detail; see p. 4 for full image), of the format commonly used for rose windows, illustrates this type of reuse. The face appears in classic frontal pose, while the hair falls in gentle waves on either side of the angel's head. The section of the cheek on the left in the image is a palimpsest, with new lines of hair added on the far left. The horizontal striations suggest that the segment was once painted with cascading hair. Presumably, the restorer took a broken section of another head from within the ensemble and employed it as a replacement piece of glass to match the same color, thickness, and texture.

An older practice of exact matching, probably from the nineteenth century, is found in the panel depicting Saint Margaret (see fig. 43). The original glass of the subject's garment exhibits an unusual pattern of uniform striations that is not found in later material. To restore the second segment of her dress (from the bottom), the restorer found a piece of glass that closely matched the original in texture and color. Under raking light, however, the neutral vitreous paint of the replacement exhibits a darker tone than the rest of her dress.

Sometimes color shifts indicate an intervention. The elaborate border in the roundel of *The Crucifixion* (fig. 71, detail; see fig. 40 for full image) shows white daisies with yellow stems and centers as well as a large flower with multiple petals seen from the side. The silver stain on the section to the right displays a decidedly orange

Fig. 71 · Detail of the border from *The Crucifixion* (fig. 40)

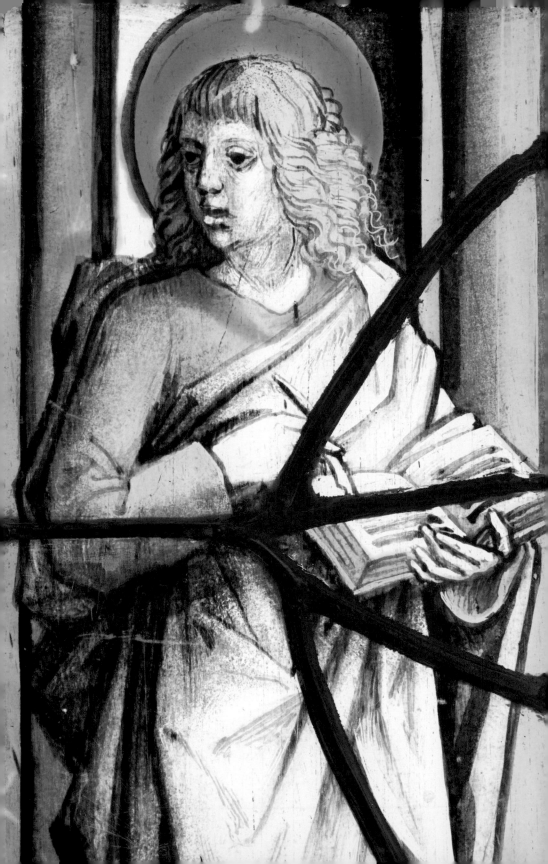

tint (compare with fig. 40), indicating that it was not created at the same time as the rest of the border. As mentioned in a previous chapter, the color produced by the silver stain technique can vary according to the chemical make-up of the glass or stain and the firing temperature.

Although glass is fragile, a well-constructed leaded and painted window is remarkably solid. The segments are held together by relatively flexible material in the lead cames, and thus can often absorb minor shifts in pressure without shattering. In the past, breakage caused by a hailstorm or careless removal, for example, was repaired by adding a mending lead. A mending lead, like any other, consists of two flanges on the top and bottom connected by a vertical segment called the heart. In earlier times restorers were often obligated to trim back the broken edges to enable them to accommodate the additional width of the came's heart. Thus, additional historical material was lost in the repair. *Saint John the Evangelist* from the southern Netherlands (fig. 72, detail; see fig. 10 for the illustration of the object after restoration) arrived at the Getty Museum with four disfiguring repair leads. These extraneous leads were removed, and the segment was mended with clear glue. The glue's acrylic infill bridged the gaps resulting from removal of the cames. Cold paint was then applied to blend the infill with its surrounding glass. The result is the restoration of the image as a uniform segment where the viewer can delight in the subtle shifts of golden tones enhancing refined draftsmanship.

Fig. 72
Detail of *Saint John the Evangelist* (fig. 10), showing repair leads before restoration

Glossary

(adapted from publications of the Corpus Vitrearum, American Committee*)

abrade (abrasion)
To grind a compositional element into the surface of glass with an iron point, file, wheel, or bit. Often, the colored layer of FLASHED GLASS, notably red and blue, was selectively removed to reveal colorless glass; the abraded area was sometimes then SILVER STAINED (*see also* ACID ETCHING).

acid etching
The selective removal, with hydrofluoric acid, of the colored layer of FLASHED GLASS (*see also* ABRADE).

armature
An iron framework set into a window opening to support panels of stained glass. The panels are held in place by wedge-shaped keys that are passed through lugs (protruding "handles") on the armature.

back-painting
Painting on the back or outer surface of glass. This is usually MATTING, either to strengthen the painted design on the inner side or to provide a decorative pattern, such as a textile design that supplements folds painted on the inner surface.

blown glass (mouth-blown glass)
Molten glass is gathered at the end of a long hollow pipe. As air is blown into the pipe, the glass forms a bubble, which can then be developed into various forms.

came
see LEAD, LEAD CAME

cartoon
A full-size drawing for a stained glass window or panel. Generally, the lead lines, details to be painted, and colors of the glass are indicated on the cartoon.

casing
see FLASHED GLASS

chef d'oeuvre
A small piece of glass inserted into a hole that has been ABRADED through a piece of glass of a different color. Medieval and Renaissance insertions are held in place with LEAD.

cross-hatching
A technique of image shading in which series of separate lines are laid at right angles to one another.

edge-bonding
A method of mending breaks in glass, normally by means of an adhesive introduced between the edges of glass.

enamel
Vitreous colorant fired on glass. Enamel consists of a base of ground glass that is colored with metallic oxide(s) and suspended in an organic medium; it can be applied to glass like PAINT.

flashed glass (variant of casing)
Glass with more than one color, most commonly an uncolored core with a surface layer of red. Sometimes multiple laminations give a streaky effect. Artists could ABRADE flashed glass to achieve both colors on a single piece of glass (*see also* POT-METAL GLASS).

grisaille
A window or panel of ornamental designs—either geometric or floral—composed almost exclusively of colorless glass, in which the designs are created by the leads alone or by adding PAINT and SILVER STAIN.

grozing
A method of shaping a piece of glass by using a notched iron bar (called a grozing iron). By pulling the iron down and away from the glass, the edge is nibbled into shape.

lead, lead came
An H-shaped strip of lead used to hold two edges

of separate pieces of glass in place to help form a panel. The crossbar of the H, which separates the two edges, is called the heart of the lead.

mat (matting)
An evenly applied layer of PAINT that usually provides a halftone shading. In the twelfth and thirteenth centuries, when mat was the preferred form of shading, it was normally applied to the glass before the TRACE.

needlework
The use of a needle to make extremely fine marks by removing paint (*see also* STICKWORK).

paint
The type of paint typically used on glass was (and still is) vitreous. Consisting of a mixture of finely ground glass, iron or copper oxide, and flux, it was applied to the glass with a brush and then fired. The binding medium, which was fired off in the heat of the kiln, was described in medieval texts as vinegar or urine and later as oil.

palimpsest
In stained glass, a piece of glass (usually dating to the period of the given panel) that has been cleaned of its original paint, usually with acid, and repainted with another design, either to restore a missing piece or to fabricate an entire panel. In manuscripts, parchment that has one text scraped off in order to write a new one. Traces of both— earlier painting in windows and earlier writing in manuscripts—may remain (*see also* STOPGAP).

pot-metal glass
Glass that is colored throughout by metallic oxides in glass composition (*see also* FLASHED GLASS).

quarry
A small, normally colorless pane of glass—usually diamond shaped or a canted square—with a SILVER STAINED and PAINTED decorative motif at its center.

sanguine
A pigment containing iron that was applied to glass; its use dates to the early fifteenth century. On firing, it acquired a transparent appearance, similar to SILVER STAIN, but varying from a rosy tint used as a flesh color to a bright red-orange.

silver stain
A transparent yellow stain produced when a mixture containing a compound of silver and a diluent—such as clay—was applied to the surface of glass and then fired. Used from the early fourteenth century on, silver stain was almost always applied to the outer surface. The color ranges from lemon yellow to deep amber.

sorting marks
Painted or engraved ciphers, on either side of pieces of glass; the ciphers may repeat within a panel, indicating that they were used for sorting the pieces after firing.

stickwork
The use of a pointed tool (traditionally, the butt of a brush, *see also* STIPPLING) to scratch details or highlights in PAINTED areas prior to firing (*see also* NEEDLEWORK).

stippling
A method of shading that involves applying a MAT and then letting in minute points of light by dabbing the paint with the butt of a brush (*see also* STICKWORK).

stopgap
A piece of old glass (not necessarily contemporary with the panel) used in restoration to fill a loss. Stopgaps can retain their incongruous painted designs, possibly turned to the outside, or can be cleaned with acid (*see also* PALIMPSEST).

trace line
A thickly PAINTED line—typically a contour—that is normally applied over the MAT.

vidimus
A preliminary sketch shown to clients, from the Latin for "we have seen."

* The Corpus Vitrearum was established in 1952 under the auspices of the Comité International d'Histoire de l'Art and the Union Académique Internationale. Dedicated to recording medieval and Renaissance stained glass, it includes twenty national committees that have published more than seventy volumes. The American Committee has published *Stained Glass before 1700 in American Collections* (see References) as well as dedicated regional volumes and studies.

References

Brieger, Peter. *English Art, 1216–1307*. Oxford, 1957.

Brown, Sarah. "Repackaging the Past: The Survival, Preservation, and Reinterpretation of the Medieval Windows of St. Mary's, Fairford, Gloucestershire." In *Art, Piety, and Destruction in the Christian West, 1500–1700*, edited by Virginia Raguin, 91–102. Farnham, Surrey, England, and Burlington, VT, 2010.

Brown, Sarah, and David O'Connor. *Medieval Craftsmen: Glass-Painters*. Toronto, 1991.

Durandus, William. *The Symbolism of Churches and Church Ornaments: A Translation of the First Book of the Rationale Divinorum Officiorum* by John Neale and Benjamin Webb. Leeds, England, 1843.

Elskus, Albinas. *The Art of Painting on Glass: Techniques and Designs for Stained Glass*. New York, 1980.

Grodecki, Louis, and Catherine Brisac. *Le vitrail gothique au XIIIe siècle*. Fribourg, 1984. Translated as *Gothic Stained Glass*. Ithaca, NY, 1985.

Hawthorne, John G., and Cyril Stanley Smith, eds. *Theophilus on Divers Arts: The Foremost Medieval Treatise on Painting, Glassmaking, and Metalwork*. New York, 1979.

Hebgin-Barnes, Penny. *The Medieval Stained Glass of Lancashire*. Corpus Vitrearum Medii Aevi: Great Britain, 8. Oxford, 2008.

Higgins, Mary Clerkin. "Origins, Materials, and the Glazier's Art," in Virginia Raguin, *Stained Glass from Its Origins to the Present*. Portions of the text in the present book are taken from Higgins's essay.

Marks, Richard. *Stained Glass in England during the Middle Ages*. Toronto, 1993.

Raguin, Virginia. *Stained Glass from Its Origins to the Present*. New York, 2003. Published in London the same year as *The History of Stained Glass*.

Smith, Elizabeth Bradford, et al. *Medieval Art in America: Patterns of Collecting, 1800–1940*. Exh. cat. University Park, Palmer Museum of Art, Pennsylvania State University, 1996.

Winston, Charles. *An Inquiry into the Difference of Style Observable in Ancient Glass Paintings, Especially in England: With Hints on Glass Painting, by an Amateur*. Oxford, 1847.

CORPUS VITREARUM PUBLICATIONS— AMERICAN COMMITTEE

Checklist Series:

Stained Glass before 1700 in American Collections, vols. 1–3, Madeline H. Caviness, ed.; vol. 4, Timothy B. Husband, ed. Studies in the History of Art, Washington, DC, 1985, 1987, 1989, 1991.

Catalogues (of private and public collections in the United States):

Burnam, Renée. *Stained Glass before 1700 in the Philadelphia Museum of Art*. London/Turnhout, 2012.

Hayward, Jane, revised and edited by Mary B. Shepard and Cynthia Clark. *English and French Medieval Stained Glass in the Collection of the Metropolitan Museum of Art, New York*. London/Turnhout, 2003 (2 vols.).

Lillich, Meredith P., and Linda Papanicolaou. *Stained Glass from before 1700 in Upstate New York*. London/Turnhout, 2004.

Raguin, Virginia C., and Helen J. Zakin with the assistance of Elizabeth C. Pastan. *Stained Glass before 1700 in the Collections of the Midwest States: Illinois, Indiana, Michigan, Ohio*. London/Turnhout, 2001 (2 vols.).

Illustration Credits

Fig. 1: © Purestock / Alamy

Fig. 2: Courtesy of Bowdoin College and Patrick Dougherty / © Patrick Dougherty, www.stickwork.net

Fig. 3: Göttingen State and University Library, 2 Cod Ms Uffenbach 40c, Bl. 38

Figs. 4, 7, 9–12, 14–15, 19, 22–23, 25–27, 29–31, 33–52, 54–56, 58–59, 62, 64–65, 67–69, 70–72: The J. Paul Getty Museum

Figs. 5, 6: LambertsGlas® Germany, www.lamberts.de

Fig. 8: Collection of the Corning Museum of Glass, Corning, NY

Figs. 13, 16, 24, 28, 61, 67: Virginia Chieffo Raguin

Fig. 17: Louise Heusinkveld / Photolibrary / Getty Images

Fig. 18: Manuel Cohen / The Art Archive at Art Resource, NY

Fig. 20: Alfredo Dagli Orti / Art Resource, NY

Figs. 21, 32: Michel Raguin

Fig. 53: Image copyright © The Metropolitan Museum of Art. Image source: Art Resource, NY

Fig. 57: Collection Rijksmuseum, Amsterdam

Fig. 60: © Trustees of the British Museum

Fig. 63: Strawberry Hill Trust / Richard Holttum

Fig. 66: Photo courtesy Mary Clerkin Higgins

Index